DRAWING On the FUNNY SIDE of THE BRAIN

DRAWING *On the* FUNNY SIDE *of* THE BRAIN

HOW TO COME UP WITH JOKES FOR CARTOONS AND COMIC STRIPS

BY CHRISTOPHER HART

WATSON-GUPTILL PUBLICATIONS • NEW YORK

Senior Editor: Candace Raney
Project Editor: Alisa Palazzo
Designer: Bob Fillie, Graphiti Graphics
Production Manager: Ellen Greene

Front and back cover art by Christopher Hart
Text and illustrations copyright © 1998 Christopher Hart

First published in 1998 by Watson-Guptill Publications,
a division of BPI Communications, Inc.,
1515 Broadway, New York, N.Y. 10036

Library of Congress Cataloging-in-Publication Data
Hart, Christopher.
 Drawing on the funny side of the brain / Christopher Hart.
 p. cm.
 Includes index.
 ISBN 0-8230-1381-2 (pbk.)
 1. Cartooning—Technique. 2. Comic strip characters. I. Title.
NC1764.H36 1998
741.5—dc21 97–31731
 CIP

Printed in Singapore

First printing, 1998

1 2 3 4 5 6 7 8 9 /06 05 04 03 02 01 00 99 98

To Isabella, Francesca, and Maria

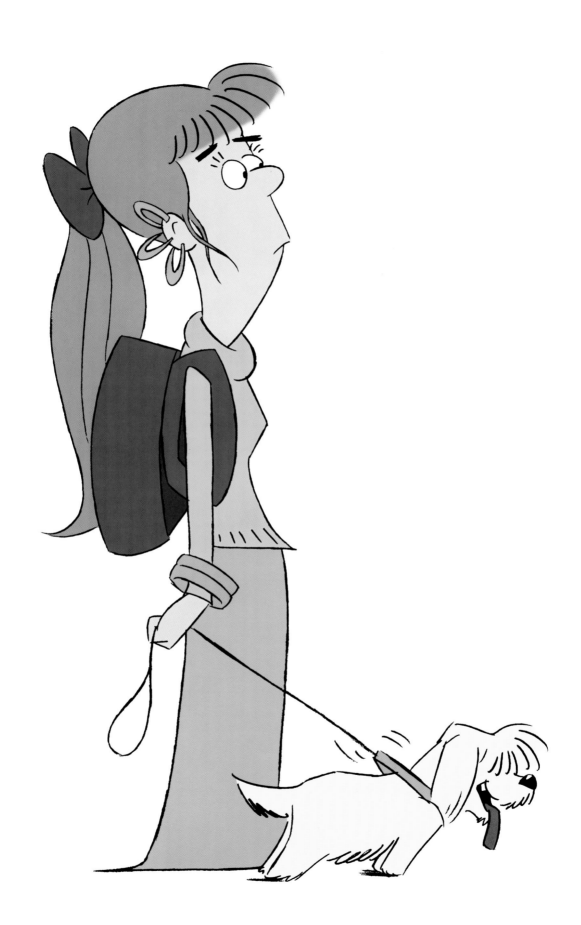

CONTENTS

INTRODUCTION

The most frequent question comic strip artists hear is, "Where do you get your ideas?" They'll respond with an "Aw, shucks," and mumble something self-effacing —but notice that they don't answer your question. You think they don't know how they do it? They produce a comic strip every day of their lives, but you really think it's a mystery to them?

Sure.

I'll show you exactly how to come up with jokes for cartoons and how to illustrate them. I'll even give you the keys to combatting writer's block. I won't tell you—as some authors do—to take strolls along the beach, clear your mind, and try to think up something funny. I can't imagine being satisfied with advice like that. If it worked, the beach would be filled with professional cartoonists. If we relied merely on inspiration, we'd all be out of work. Joke and gag writing is a *craft,* not an art. What if you called your plumber to fix a leak, but he said he was waiting until he felt "inspired" to plumb? This shouldn't happen to you as a cartoonist; you can be funny even when you don't feel funny, once you have the key.

This book is also very much about drawing, as well as writing. If you want to know how to draw funny—funny enough to get a laugh and funny enough to get published—then this book is for you. You'll learn all the basics of cartooning, plus how to invent humorous characters, how to draw sly expressions, how to design bodies for specific personality types, how to draw tough hand poses with ease, when to simplify, when to exaggerate, how to create funny animals, and much more. In addition, as a special feature, there's an exclusive interview with Wallace Collins, a highly regarded copyright attorney, who'll explain exactly how to protect your ideas.

You'll also learn everything you need to know to sell your own comic strip, including how to package your submissions to newspapers and syndicates in a way that immediately elevates your work above that of the novice. In addition, you'll get the addresses of the top newspaper comic strip syndicates that are looking for the next *Garfield.* Hey, yours could be the one.

DRAWING FUNNY CHARACTERS

Man has been making funny drawings since the beginning of time. Cave paintings are filled with lion-rips-hunter-to-shreds gags, which, frankly, were a bit over the top but at least they had a premise. To learn about humor, a good question to ask is, What makes a drawing funny? An even better one is, What techniques can I use to make my drawings funnier? Whatever happened to that lady who sang "I Will Survive"? is, perhaps, the best question of all but way off the subject. Stop distracting me.

The first section of this book shows you how to create characters so amusing that your readers are primed to laugh before they even get to the joke. If readers like your characters, they'll want to like the joke. A visually appealing character creates a bond with readers, inspiring loyalty. That's why characters, not jokes, are licensed on lunch boxes, mugs, and toys.

Humorous Head Construction

Following a step-by-step approach like the one shown here helps cartoonists who must draw the same character repeatedly in different poses.

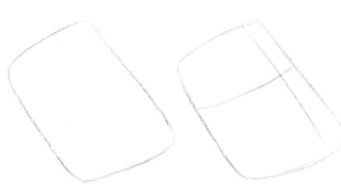
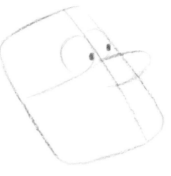
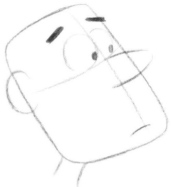

Start with a simplified shape, such as a soft-edged rectangle.

Put in some guidelines. The vertical line, known as the center line, always runs lengthwise down the middle of the face. The horizontal line, however, can be raised or lowered, depending on where you want the eyes and nose.

The bridge of the nose falls at the point where the guidelines intersect. The eyes perch on the horizontal line.

The ears also fall on the horizontal line. Be bold with the eyebrows. Unless your characters are leading-man types or are fat, give them skinny necks. It's funnier.

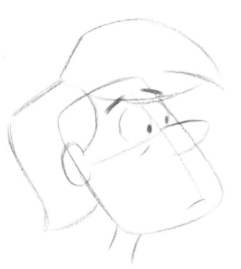
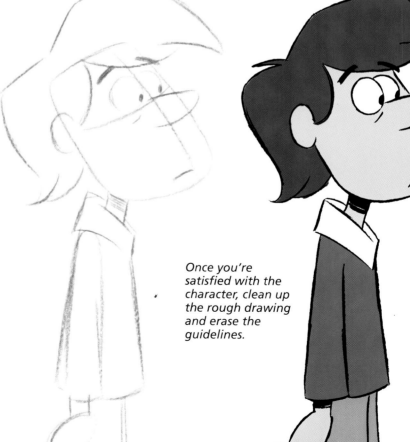

The hairstyle is a primary feature, completing a total look. Give it some thought. Wild styles are imperative for radical characters. On the other hand, straight-laced characters will have tidy hairstyles. This affable fellow has a casual, breezy cut. The style can be your own invention, but it needs to be something. After creating the hair, rough in the rest of the character.

Once you're satisfied with the character, clean up the rough drawing and erase the guidelines.

Personality and the Features

Again, start with a simplified shape—in this case, a pie wedge.

A character's facial features must mirror its personality. You can't give a male character goofy glasses and then draw the rest of him as a leading man. The two personas don't have anything to do with each other. Goofy glasses go with a receding chin and so on. Examine your rough drawing, and continue to revise it until all of the features you create support your character's personality.

Here, for example, I exaggerated the construction of this lady's head by making it flat on the top and side. All of this flatness helps to define a *flat* personality. I underscored this by giving her a droll expression—those droopy eyelids get the message across. Also, her lips are stretched out in a slightly downward curve as if no amount of energy can curl them up into a smile. Even the hair behind her head is flat.

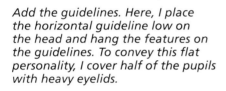

Add the guidelines. Here, I place the horizontal guideline low on the head and hang the features on the guidelines. To convey this flat personality, I cover half of the pupils with heavy eyelids.

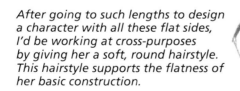

After going to such lengths to design a character with all these flat sides, I'd be working at cross-purposes by giving her a soft, round hairstyle. This hairstyle supports the flatness of her basic construction.

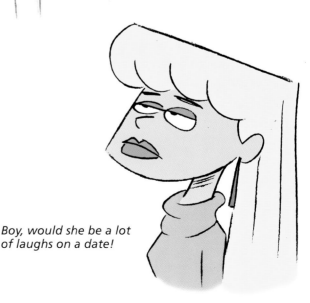

Boy, would she be a lot of laughs on a date!

Even a more complex head shape should be broken down into a simple form.

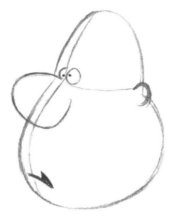

Exaggerate the size of the features, increasing some while decreasing others, and alternate the sizes. Put big shapes with little ones. For example, here the eyes are small, the nose is large, and the ears are small again. These contradictions create a humorous effect.

Next time you go for a stroll, pick up a few newspapers that have good comics sections. (For you folks in Los Angeles, don't panic; you don't actually have to *walk* to a newsstand—you can drive there.) Notice how small the comic strips are. Keep this in mind because if you like to add lots of detail, you'll end up with a comic strip that becomes muddy when it's reduced to newspaper size.

Clarity is essential in humor. A joke happens in an instant or it doesn't happen at all. Complex shapes are harder to read, and they tend to compete with one another. On the crowded comics page, if readers' eyes wander just a fraction of an inch, they're already looking at the next comic strip, and you're history, babe. To prevent this from happening, simplify some of your character's features and exaggerate others.

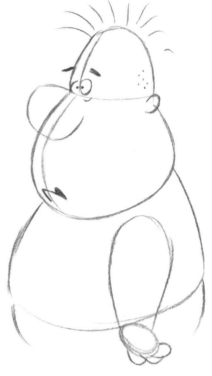

Note the simplicity of the features. The eyes are round instead of almond shaped. There are no nostrils. The inside of the ear has no detail. The expression lines are kept to a minimum or eliminated completely.

Attitude

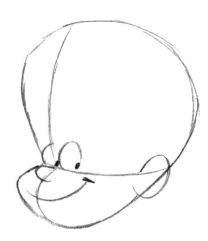

The best way to communicate an attitude is by sheer voltage. Pump up the energy level of your characters so that they radiate personality. Focus primarily on the shape of the eyes and the mouth, particularly where the mouth wedges into the cheek. Also, be singular in purpose; don't make your character a little mischievous *and* a little sloppy. He's either a rogue *or* a slob. Don't straddle the fence.

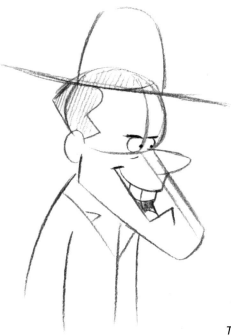

This very officious fellow has beady little eyes, a square jaw, a pointy nose, and no neck. His whole demeanor says "intense."

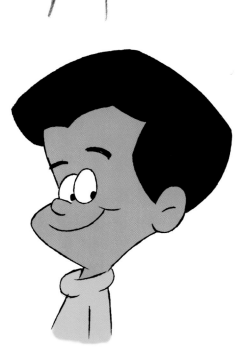

Here's a perky kid. You can see it in his eyes and his sideways glance. His smile goes high up into his cheek—it's not a middle-of-the-road grin.

It takes a lot of work to own a dog, and what do you get in return? You get to pet it. What's that? Some great reward? "Okay master, here's the deal: You buy the food, walk me, and groom and bathe me, and in return, I'll wag my tail every time I see you. Oh yeah, one more thing—I'm going to have an accident on your carpet. Can't tell you when, can't tell you why, but just know that it's going to

happen." And people voluntarily sign on for this? I don't think so.

I'll cover animals in depth later on (see pages 45–54), but just to give you a sample of what's to come, let's get our paws wet now. In almost all animals, the basic head and face construction centers around a protruding snout, as with the dog below. In addition, small details add personality.

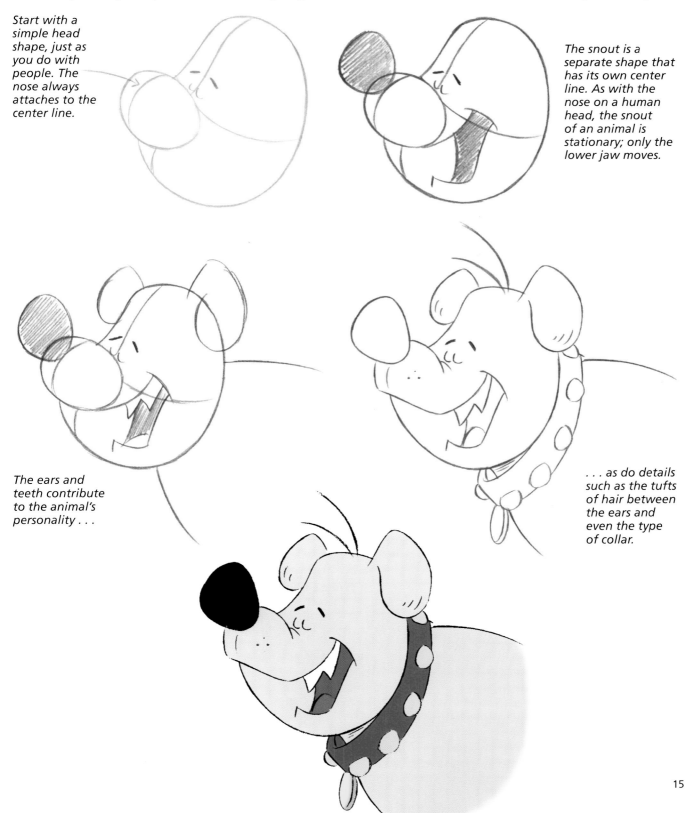

Start with a simple head shape, just as you do with people. The nose always attaches to the center line.

The snout is a separate shape that has its own center line. As with the nose on a human head, the snout of an animal is stationary; only the lower jaw moves.

The ears and teeth contribute to the animal's personality . . .

. . . as do details such as the tufts of hair between the ears and even the type of collar.

Developing a Consistent Style

As a professional comic strip artist, you'll want to have a stable of characters that appear to be drawn by the same hand. Readers find comfort with this sense of familiarity. You can achieve a unique (and consistent) style of drawing, either by adapting an existing style or creating one of your own. However, this can take time. There's an easier way.

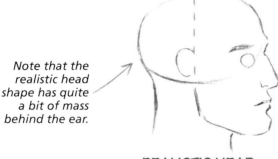

Note that the realistic head shape has quite a bit of mass behind the ear.

REALISTIC HEAD

CARTOON HEAD
Cartoon heads typically eliminate much of the mass behind the ear. This makes for a funnier-looking head.

VARIATIONS ON A BASIC CARTOON HEAD SHAPE
Instead of inventing a new character from scratch each time, use the same basic head shape for all the characters in your strip. Reinvent only each character's individual features, hanging them interchangeably on that basic head shape. Without consciously knowing why, readers will sense that all of the characters share a commonality. All the heads on these two pages share the same basic shape and are therefore consistent in style.

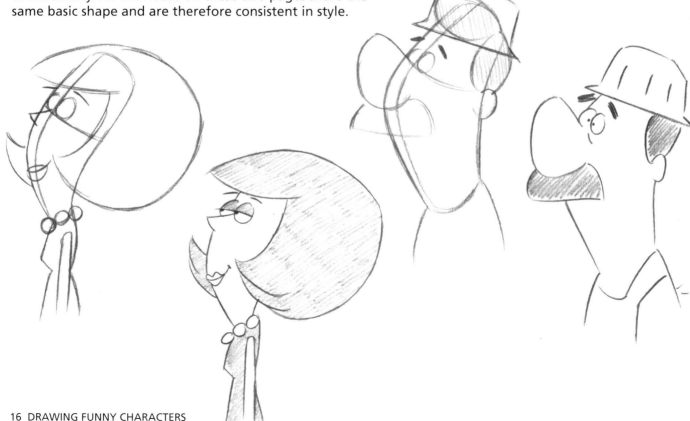

Getting to Know Your Characters

I'm not suggesting some psychotic exercise in which you actually talk to your cartoons. You won't learn anything from that, and your cartoon characters will resent your little chats. What I mean is that you should learn how to draw your characters from all angles. If you don't, you'll unconsciously start favoring certain *easier-to-draw* angles. You'll end up staging a scene *less effectively,* simply to avoid drawing a 3/4 rear shot or a profile. If you're having trouble drawing a character in a new position, go back to its basic construction for guidance.

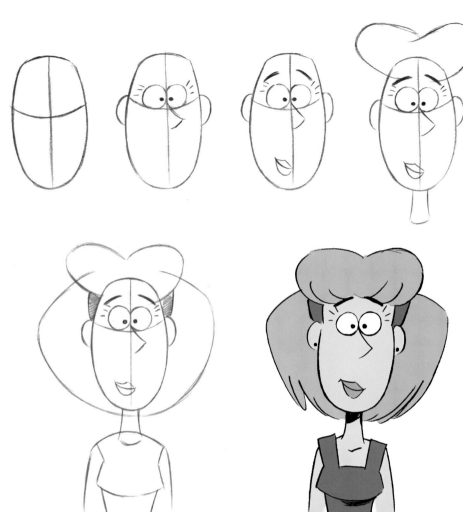

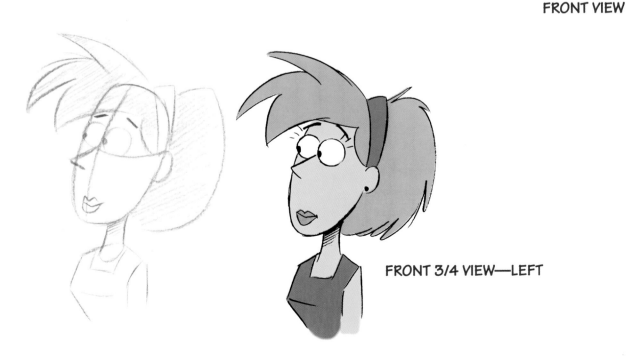

FRONT VIEW

FRONT 3/4 VIEW—LEFT

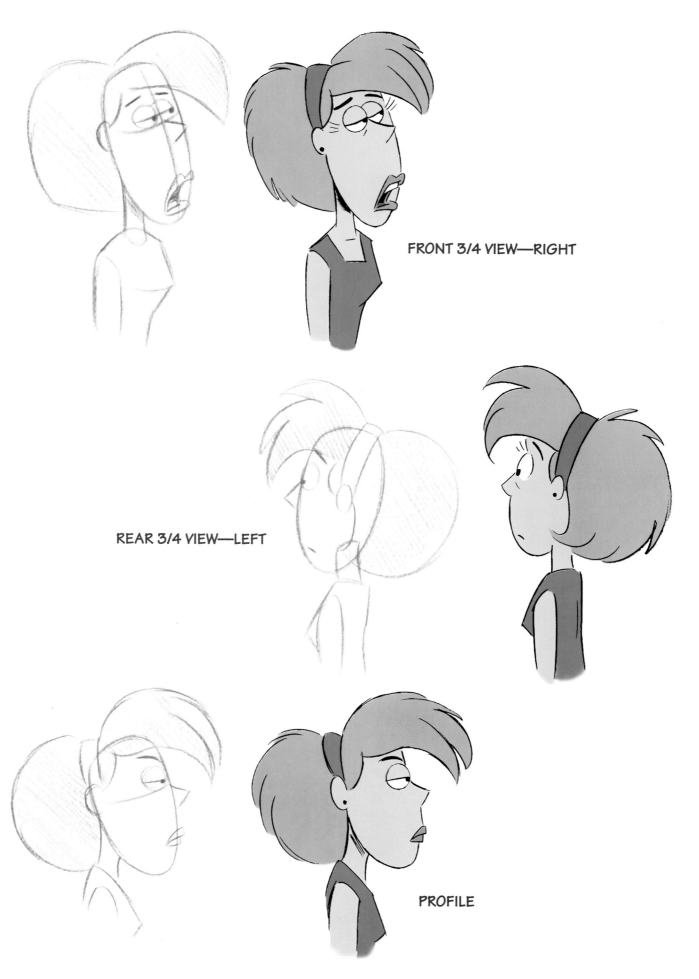

FRONT 3/4 VIEW—RIGHT

REAR 3/4 VIEW—LEFT

PROFILE

Creating Different Looks by Shifting the Features

The eyes and the nose fit together snugly on the face as a unit. Raising or lowering this unit of features on the face can alter the look of a character. The mouth, however, may remain in the same place, independent of the position of the eye-nose unit. Generally, the longer the distance between the nose and the mouth, the funnier the look will be.

LOW EYE-NOSE UNIT

HIGH EYE-NOSE UNIT

TRUE PROPORTIONS

When the mouth is closed, the eyes appear exactly in the middle of the head. The head is approximately five eye lengths across, and the eyes are about one eye length apart from each other. The top of the ears are on the same level as the eyebrows.

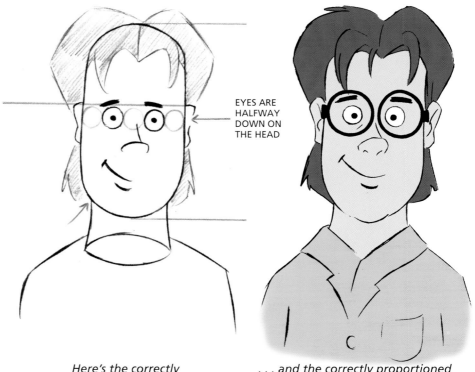

EYES ARE HALFWAY DOWN ON THE HEAD

Here's the correctly proportioned drawing . . .

. . . and the correctly proportioned cartoon version.

HUMOROUS VARIATIONS

Most cartoon characters, unless they're children or cute characters, have eyes positioned toward the top of the head. You can also use other techniques to exaggerate the true proportions.

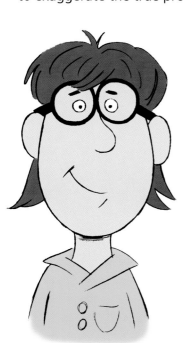

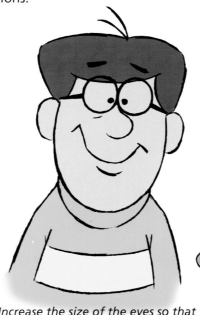

Decrease the size of the eyes so that the head is seven eye lengths across.

Increase the size of the eyes so that the head is only three eye lengths wide, and stick the eyes together without any space between them. Pushing the eyes together conveys a sense of wackiness. Let the eyeglass rims serve as huge eyeballs.

Eliminate the eyeballs entirely and enlarge the glasses. This always creates a quirky look. However, note that although this is a funny effect, it'll cost you in terms of personality; there are only so many expressions you can create without the eyes.

Cheats: The Eyes

Cheating is an animator's term that means graphically depicting something in a way that *looks* good but really is physically impossible. The eyes are a popular feature with which to cheat because they add so much character to the face. Cartoonists use "cheats" as a way to stylize their characters—to give them an edge. Here are some examples.

EYES ON TOP OF THE HEAD

BOTH EYES ON SAME
SIDE OF THE HEAD

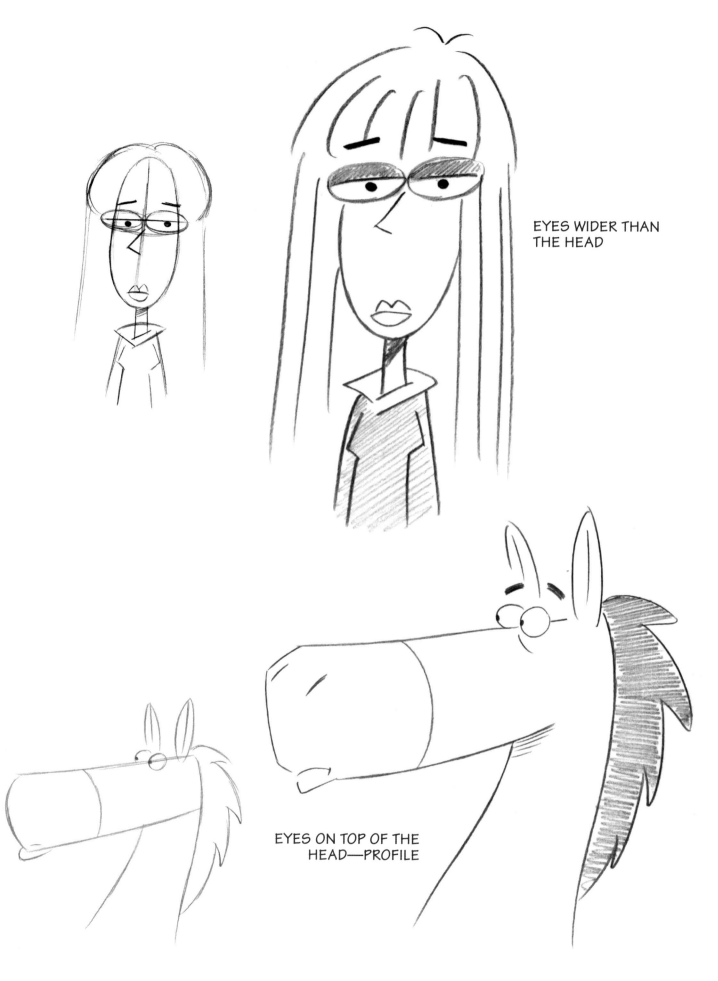

EYES WIDER THAN
THE HEAD

EYES ON TOP OF THE
HEAD—PROFILE

Funny Expressions

In animation, the animator *pushes* an expression to the breaking point to get more energy and vitality. The broader, the better. Animation requires very little effort on the part of the audience; the camera angles and edits seamlessly manipulate the viewers' every emotional response. They expect *it* to entertain *them*.

In printed mediums, however, such as comic strips, magazine spot gags, editorial cartoons,

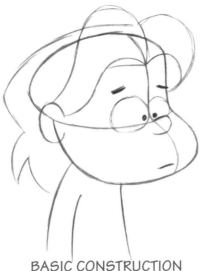

BASIC CONSTRUCTION

greeting cards, advertising, and children's book illustration, it's generally best to *underplay* expressions. Printed mediums expect readers to pay closer attention to the material. People have to *read* it, investing more time and effort in the experience. As a result, the cartoonist can afford to be a little more droll, a little more coy. Note the wide variety of subtle facial expressions that are possible with one character.

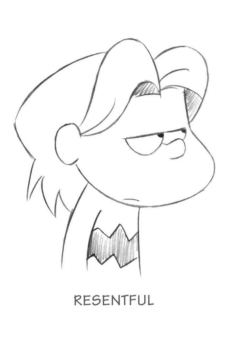

RESENTFUL

SELF-ASSURED

DOUBTFUL GLANCE

OPTIMISTIC

ANNOYED

DROLL

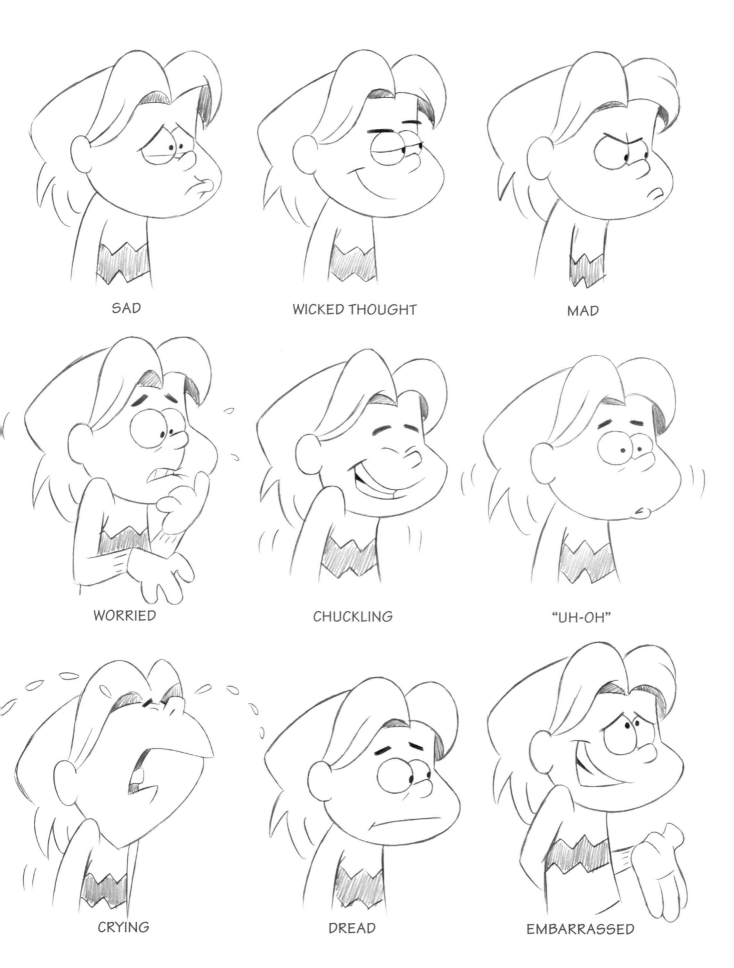

SAD

WICKED THOUGHT

MAD

WORRIED

CHUCKLING

"UH-OH"

CRYING

DREAD

EMBARRASSED

Funny Bodies

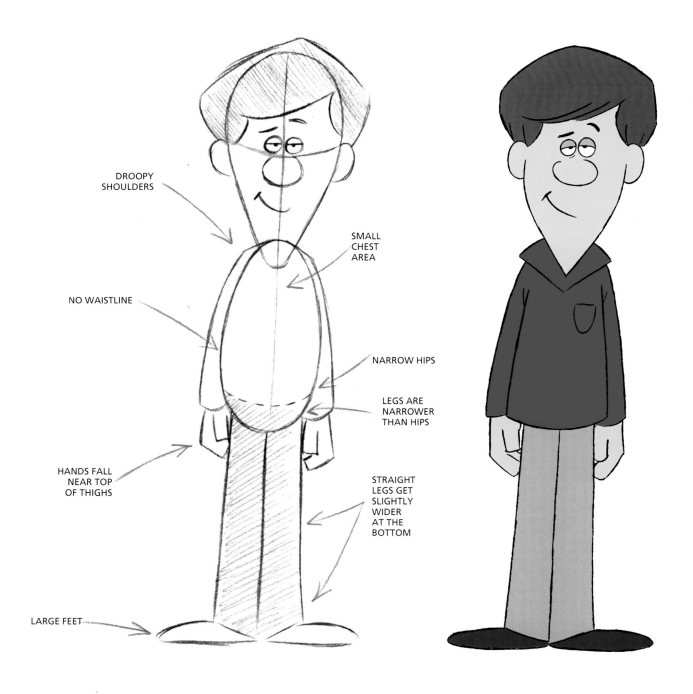

DROOPY
SHOULDERS

SMALL
CHEST
AREA

NO WAISTLINE

NARROW HIPS

LEGS ARE
NARROWER
THAN HIPS

HANDS FALL
NEAR TOP
OF THIGHS

STRAIGHT
LEGS GET
SLIGHTLY
WIDER
AT THE
BOTTOM

LARGE FEET

YOUR AVERAGE JOE

This is your "average" male body. About 5' 10", 165 pounds
with a cholesterol level pushing 200. Of course, the average
varies. In your neck of the woods, an average man might be
5' 8" and 200 pounds. But then, I'd say your family has been
riding those desserts pretty hard, fella. In general, the average
body type is perfect for a dad or an employee character.
Note the identifying features.

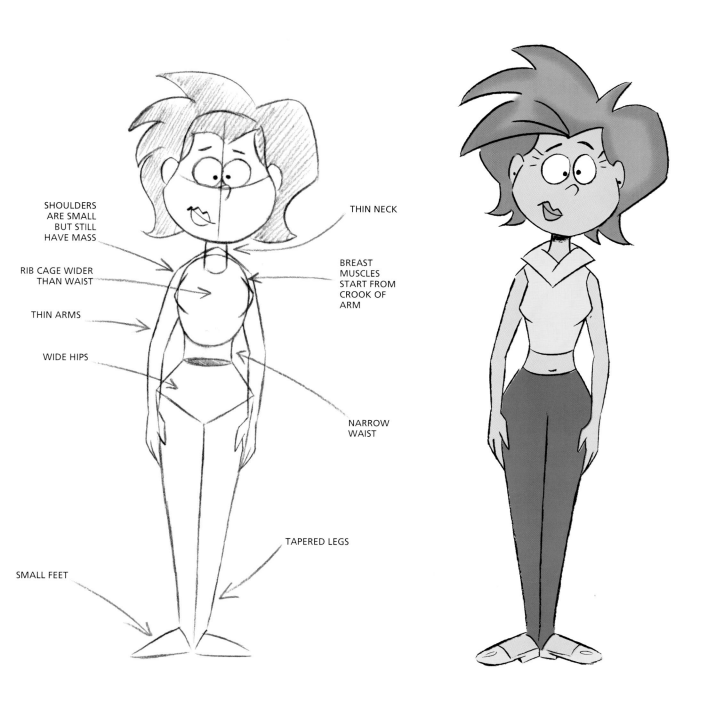

SHOULDERS ARE SMALL BUT STILL HAVE MASS

RIB CAGE WIDER THAN WAIST

THIN ARMS

WIDE HIPS

SMALL FEET

THIN NECK

BREAST MUSCLES START FROM CROOK OF ARM

NARROW WAIST

TAPERED LEGS

YOUR AVERAGE JANE

This is your "average" female body. But, again, the average can vary. She's about 5'4", and she is a comfortable weight— not a supermodel. You want people to relate to her. She's a mom, a career professional, a friend, or a neighbor.

How to Draw the Cartoon Hand

Drawing hands is a problem for many people. You know who you are. You're the ones sitting way in the back at cartoonist conventions not having any fun. Years of therapy won't solve this problem—all you'll wind up with is a lot of bills your insurance won't cover and a really low opinion of your parents. There's a better way.

The first thing to realize is that anytime you're having trouble drawing a hand pose, you've got the ultimate reference right at your side: your own hand. Strike a hand pose, look at it, and draw it. It's amazing how people spend hours struggling to draw a hand without ever even looking at one. Think *cute and chunky* when drawing hands. Think *personality*. Hands are very expressive. You can draw them with three or four fingers; it really doesn't matter as long as you keep the number consistent for each character.

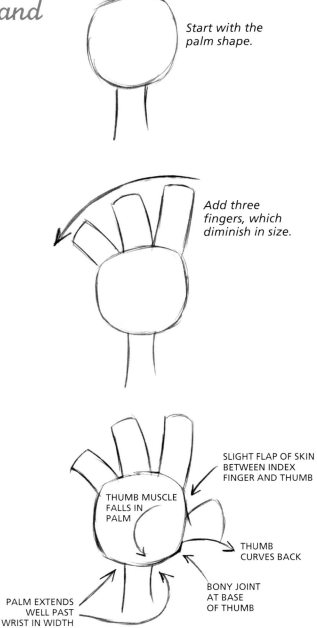

Start with the palm shape.

Add three fingers, which diminish in size.

SLIGHT FLAP OF SKIN BETWEEN INDEX FINGER AND THUMB

THUMB MUSCLE FALLS IN PALM

THUMB CURVES BACK

BONY JOINT AT BASE OF THUMB

PALM EXTENDS WELL PAST WRIST IN WIDTH

Add the thumb and the thumb muscle.

THE BONES OF THE FINGERS AND THUMB

Fingers have three moveable bones in them. The thumb also has three moveable bones. The first thumb bone, which most people mistakenly believe is an immobile part of the hand, is buried in your thumb muscle. If you move your thumb toward your pinky finger, you can see just how far this bone moves; none of the other bones of the palm can move like this.

Cartoonists usually eliminate the last bone of the fingers, drawing fingers that have only two joints. The thumb, however, retains three joints.

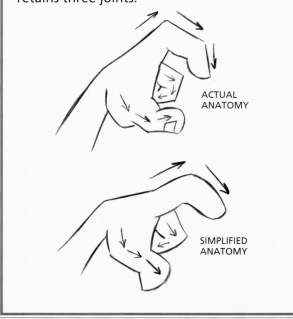

ACTUAL ANATOMY

SIMPLIFIED ANATOMY

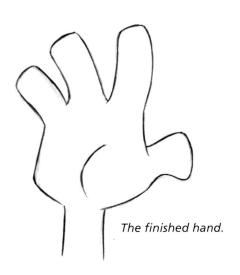

The finished hand.

STEP-BY-STEP HAND CONSTRUCTION—SIDE VIEW

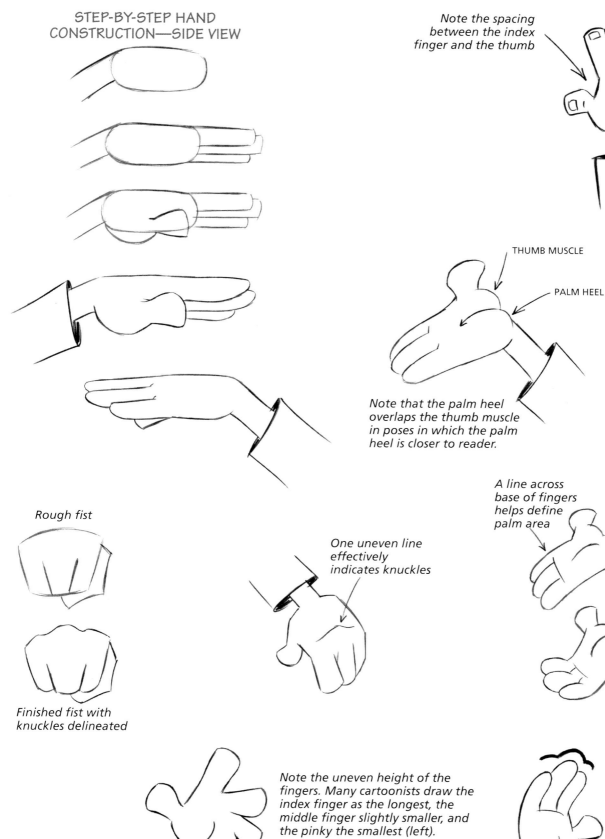

Note the spacing between the index finger and the thumb

THUMB MUSCLE

PALM HEEL

Note that the palm heel overlaps the thumb muscle in poses in which the palm heel is closer to reader.

Rough fist

Finished fist with knuckles delineated

One uneven line effectively indicates knuckles

A line across base of fingers helps define palm area

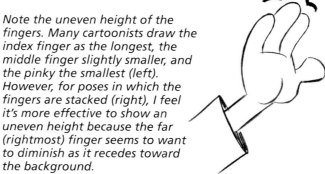

Note the uneven height of the fingers. Many cartoonists draw the index finger as the longest, the middle finger slightly smaller, and the pinky the smallest (left). However, for poses in which the fingers are stacked (right), I feel it's more effective to show an uneven height because the far (rightmost) finger seems to want to diminish as it recedes toward the background.

HANDS IN ACTION

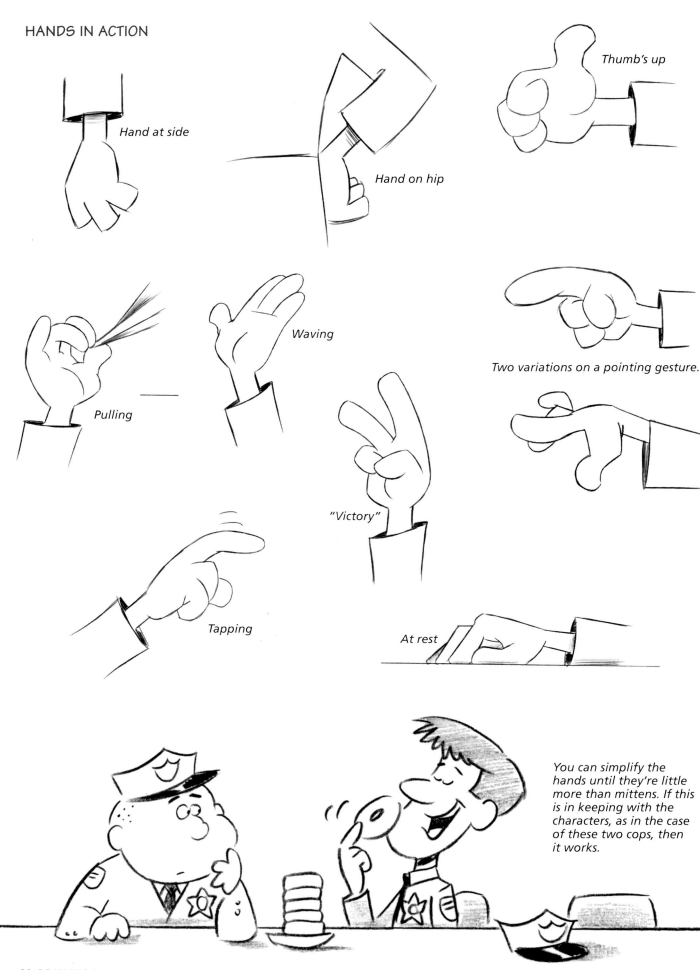

Hand at side

Hand on hip

Thumb's up

Pulling

Waving

Two variations on a pointing gesture.

"Victory"

Tapping

At rest

You can simplify the hands until they're little more than mittens. If this is in keeping with the characters, as in the case of these two cops, then it works.

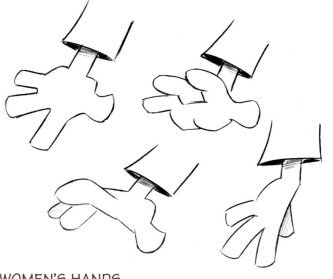

WOMEN'S HANDS

Most female hands are drawn with four fingers rather than three. This is because the female body is typically drawn more realistically than the male body. The male figure is more of a caricature, derived from a simple shape, like an oval. But the female form is more complex due to the wide chest/narrow waist/wide hips design. Women's hands, therefore, must be drawn more realistically to be consistent with the body. Note that female fingers must taper, and that three fingers don't look as good as four on women's hands.

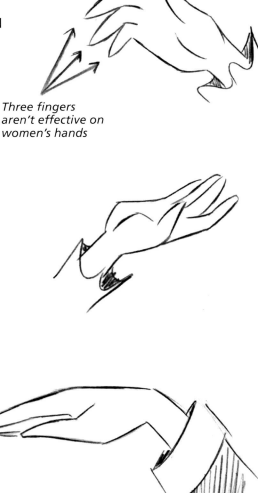

Three fingers aren't effective on women's hands

Character Types

Readers have certain expectations before ever laying eyes on a character. If they think of children, they expect them to be cute; even if the child's a troublemaker, readers still expect certain kid-like features. Bad guys will have cold eyes, and so on. Yes, it's fun to break the mold, and if you're into cutting-edge stuff, you can break free of stereotypes and shock people. However, most commerce occurs in the mainstream, not on the periphery, of the business. The "cutting edge" trickles down to the mainstream, where the best stuff is appropriated and the worst is discarded.

If you want to draw characters that the majority of readers will relate to and embrace in good humor, then you've got to incorporate certain basic, expected attributes. You could draw a maniacal kid who kills cats—I'm not saying you can't do that—but it's doubtful you'll find a big audience for this (outside of the clinic where you get your treatments). Here are a few standard character types.

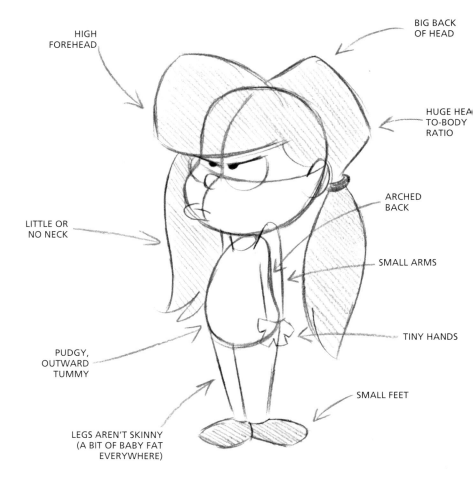

HIGH FOREHEAD

BIG BACK OF HEAD

HUGE HEAD-TO-BODY RATIO

ARCHED BACK

LITTLE OR NO NECK

SMALL ARMS

TINY HANDS

PUDGY, OUTWARD TUMMY

SMALL FEET

LEGS AREN'T SKINNY (A BIT OF BABY FAT EVERYWHERE)

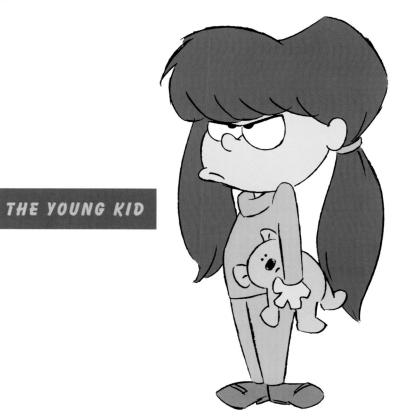

THE YOUNG KID

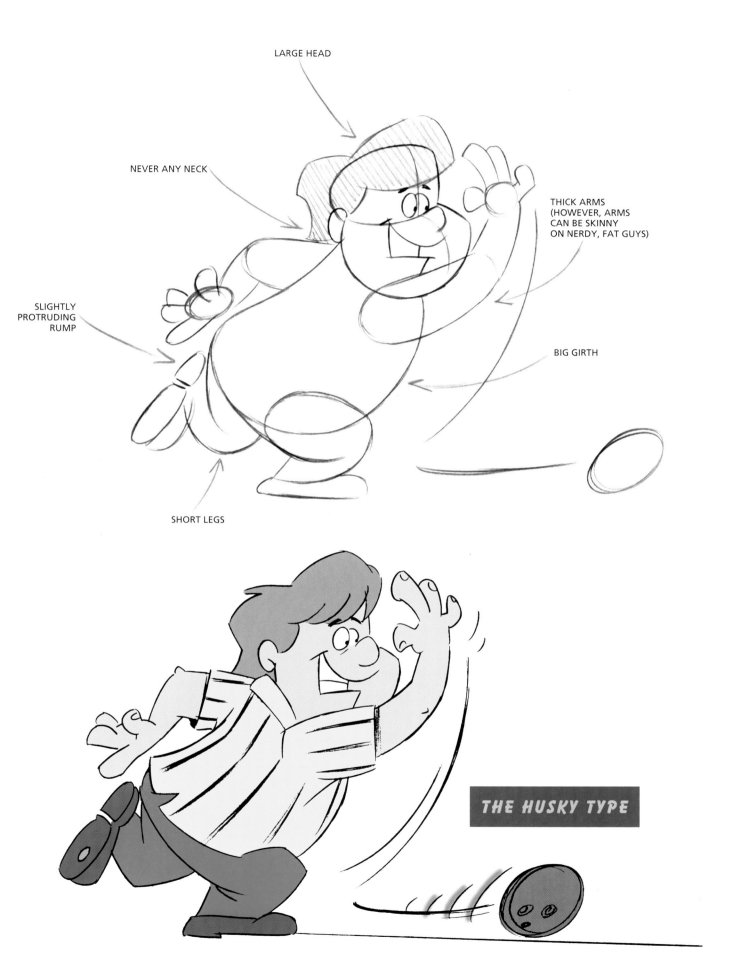

LARGE HEAD

NEVER ANY NECK

THICK ARMS
(HOWEVER, ARMS
CAN BE SKINNY
ON NERDY, FAT GUYS)

SLIGHTLY
PROTRUDING
RUMP

BIG GIRTH

SHORT LEGS

THE HUSKY TYPE

33

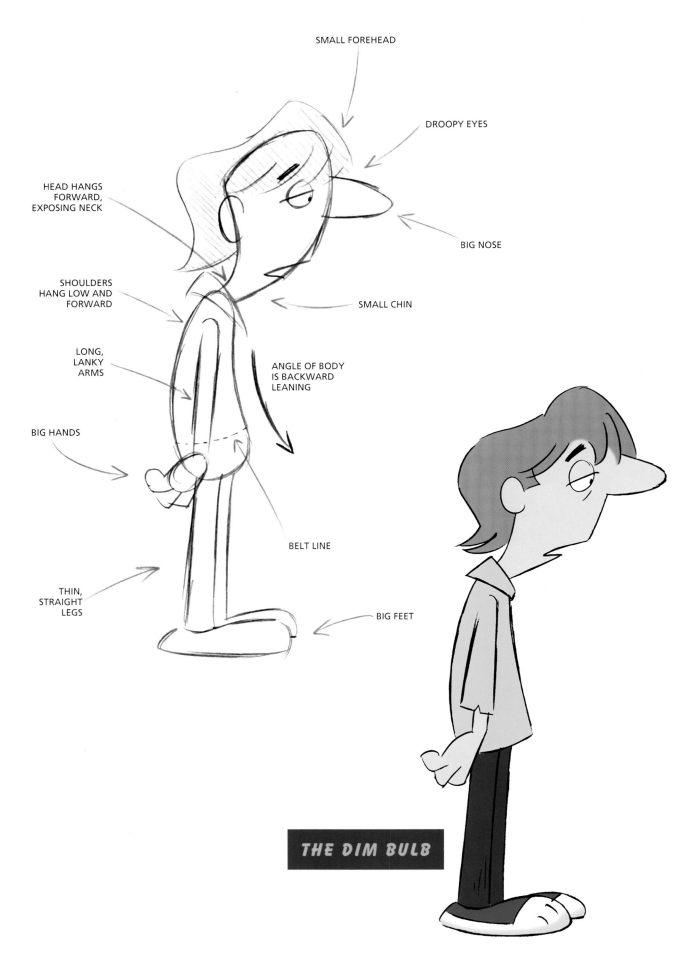

SMALL FOREHEAD

DROOPY EYES

HEAD HANGS
FORWARD,
EXPOSING NECK

BIG NOSE

SHOULDERS
HANG LOW AND
FORWARD

SMALL CHIN

LONG,
LANKY
ARMS

ANGLE OF BODY
IS BACKWARD
LEANING

BIG HANDS

BELT LINE

THIN,
STRAIGHT
LEGS

BIG FEET

THE DIM BULB

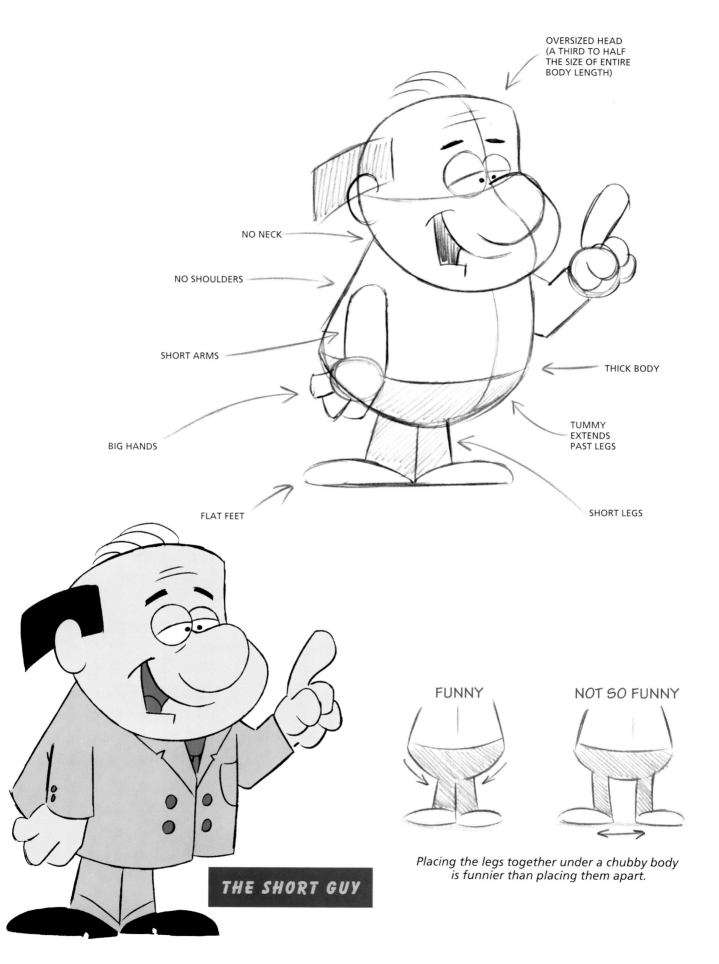

OVERSIZED HEAD (A THIRD TO HALF THE SIZE OF ENTIRE BODY LENGTH)

NO NECK

NO SHOULDERS

SHORT ARMS

BIG HANDS

FLAT FEET

THICK BODY

TUMMY EXTENDS PAST LEGS

SHORT LEGS

THE SHORT GUY

FUNNY

NOT SO FUNNY

Placing the legs together under a chubby body is funnier than placing them apart.

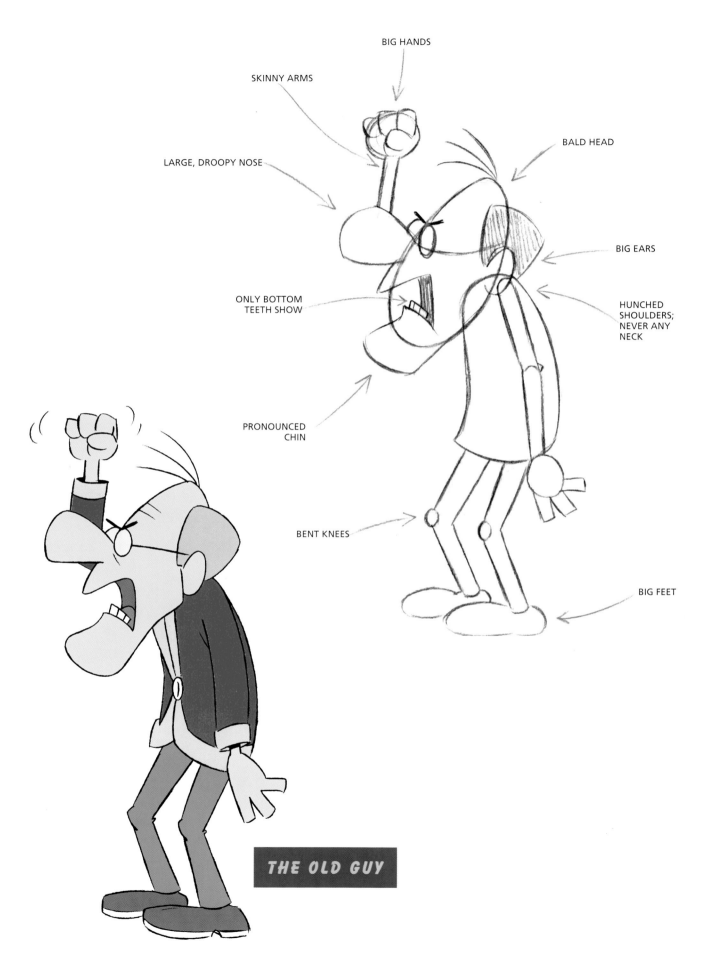

BIG HANDS

SKINNY ARMS

BALD HEAD

LARGE, DROOPY NOSE

BIG EARS

ONLY BOTTOM
TEETH SHOW

HUNCHED
SHOULDERS;
NEVER ANY
NECK

PRONOUNCED
CHIN

BENT KNEES

BIG FEET

THE OLD GUY

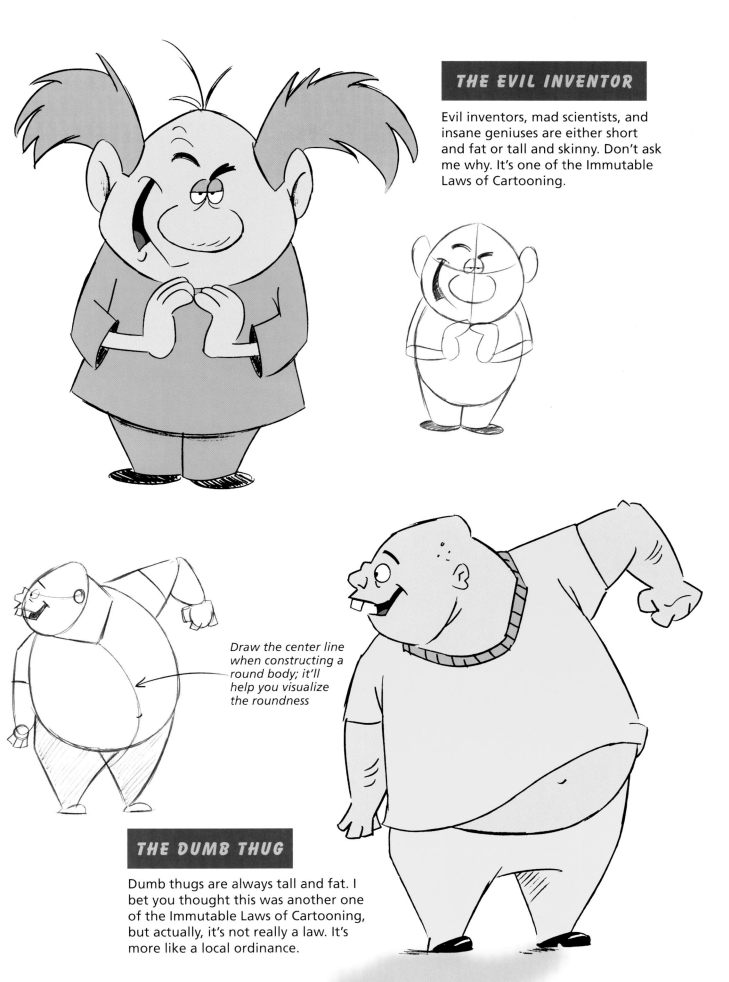

THE EVIL INVENTOR

Evil inventors, mad scientists, and insane geniuses are either short and fat or tall and skinny. Don't ask me why. It's one of the Immutable Laws of Cartooning.

Draw the center line when constructing a round body; it'll help you visualize the roundness

THE DUMB THUG

Dumb thugs are always tall and fat. I bet you thought this was another one of the Immutable Laws of Cartooning, but actually, it's not really a law. It's more like a local ordinance.

THE TRENDY LADY

Trendy and leading ladies have hourglass figures. Yeah, yeah, I know, I'm sending the wrong message by saying that a woman has to be thin and good looking in order to be a leading lady. So you go ahead and draw your 180-pound babe as the romantic lead in your comic strip, and let me know how you make out trying to sell it.

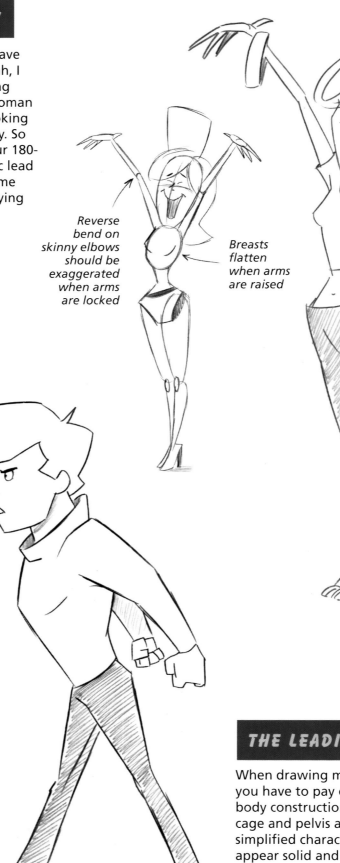

Reverse bend on skinny elbows should be exaggerated when arms are locked

Breasts flatten when arms are raised

THE LEADING MAN

When drawing more realistic characters, you have to pay closer attention to the body construction (especially in the rib cage and pelvis areas) than you do with simplified characters. The body must appear solid and not as if it were made of rubber. Leading men always have wide chests, narrow waists, rugged jaws, thick necks and shoulders, and slim legs.

Even the simple action of running can be humorous. When you get a good pose for your character, see if you can find a way to go one better. This is called *tweaking.* As illustrated by the three running figures below, most often a small adjustment can make all the difference.

FUNNY

FUNNIER

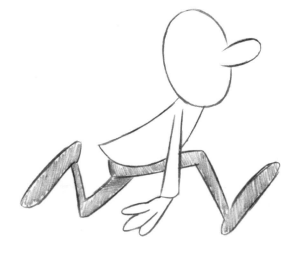

FUNNIEST

Period Costumes

When creating period costumes, be suggestive, not literal. Pick the first three things that come to mind when you think of a costume from a particular time in history, draw those things, and lose the rest.

Try to pick universally recognizable items, even if they're not completely accurate. For example, during the time of the King Arthur legend (the 6th century), knights didn't wear armor, because horseshoes hadn't been invented yet and armor weighs so much that it would have split the horses' hooves. Still, you'll never see a drawing of King Arthur without his *armored* knights. That's because it's more important to draw what people *think of* when they imagine a time in history than to draw what was literally true of that period. Remember that you're entertaining general readers, not archaeologists. (Not that archaeologists don't have great senses of humor—I hear they're a real riot.)

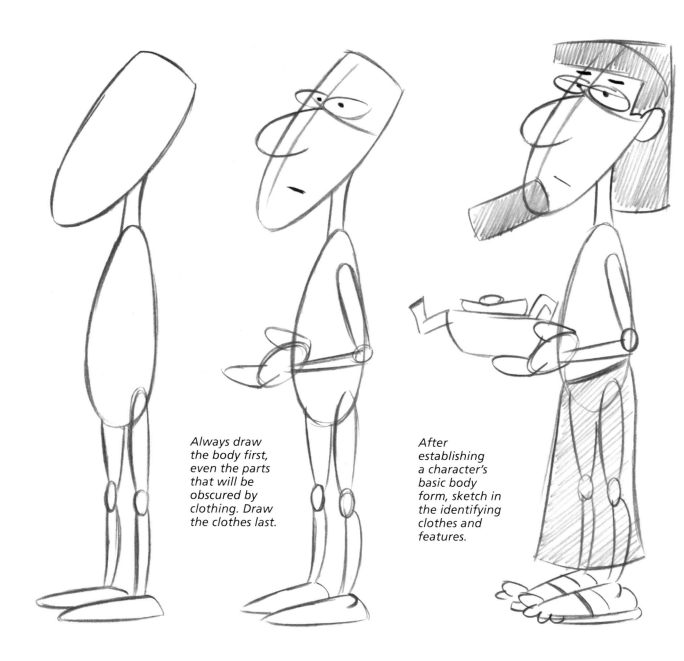

Always draw the body first, even the parts that will be obscured by clothing. Draw the clothes last.

After establishing a character's basic body form, sketch in the identifying clothes and features.

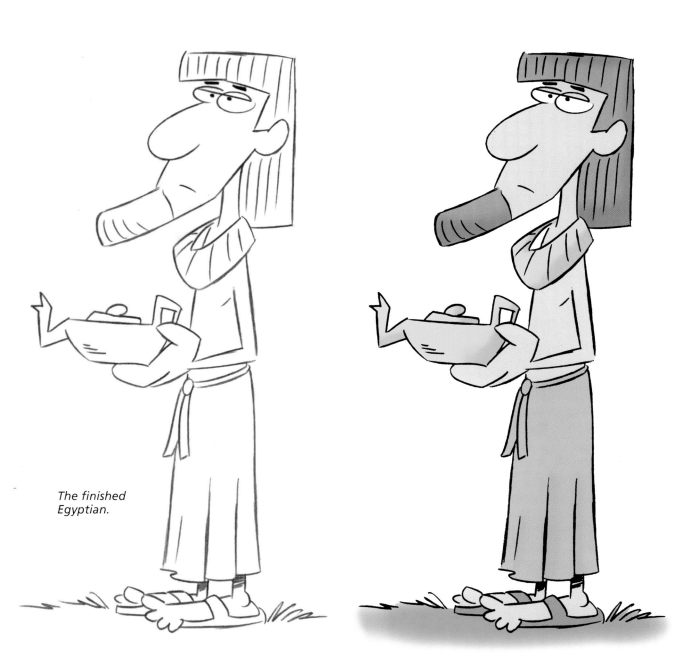

The finished
Egyptian.

Modern Costume Stereotypes

Not all chefs are French, but if I see a guy with a French mustache in a chef's hat, I instantly know his occupation. If it's a restaurant gag, and your readers have to wonder, even for a moment, who the chef is, you're cooked. As with period costumes, don't get hung up on being literal. Forget about all the medals and rankings on a cop uniform—a badge is enough. Less is better.

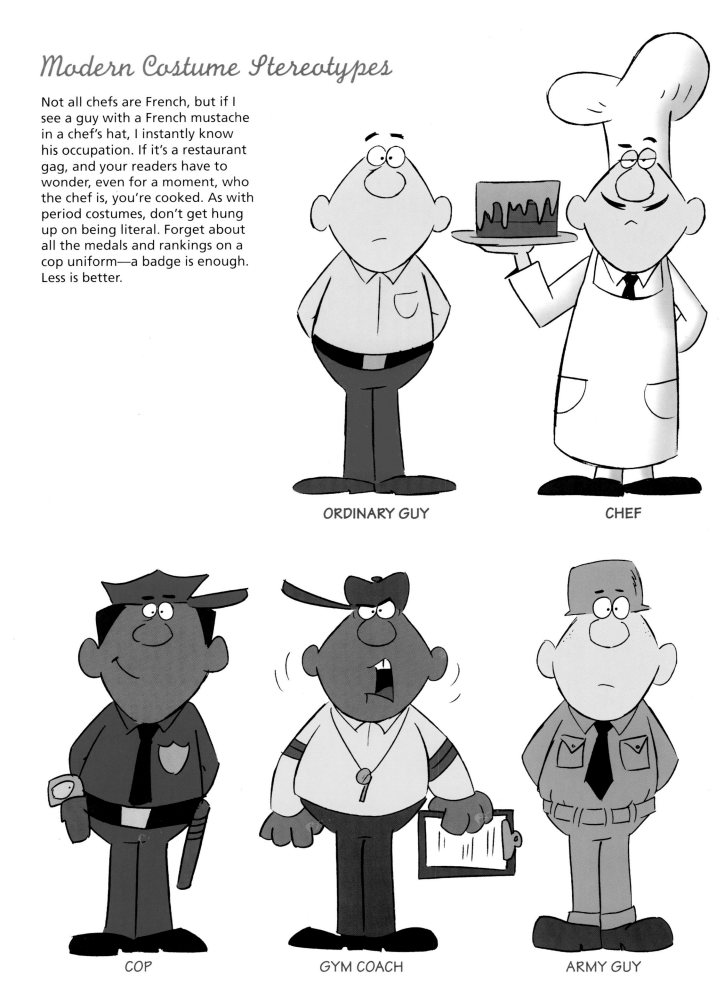

ORDINARY GUY

CHEF

COP

GYM COACH

ARMY GUY

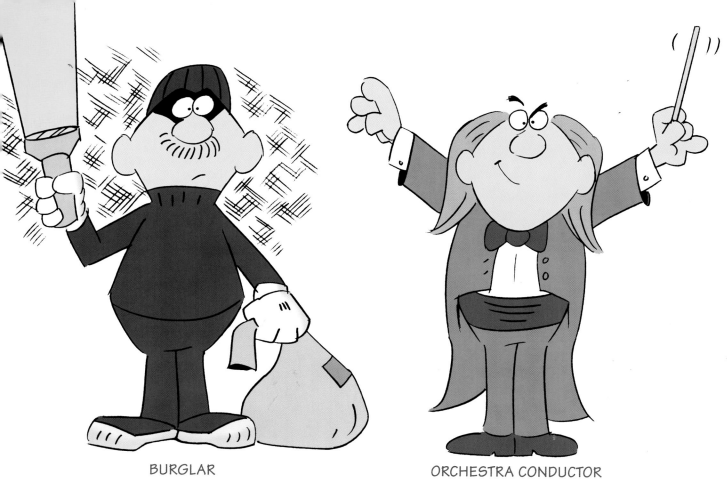

BURGLAR

ORCHESTRA CONDUCTOR

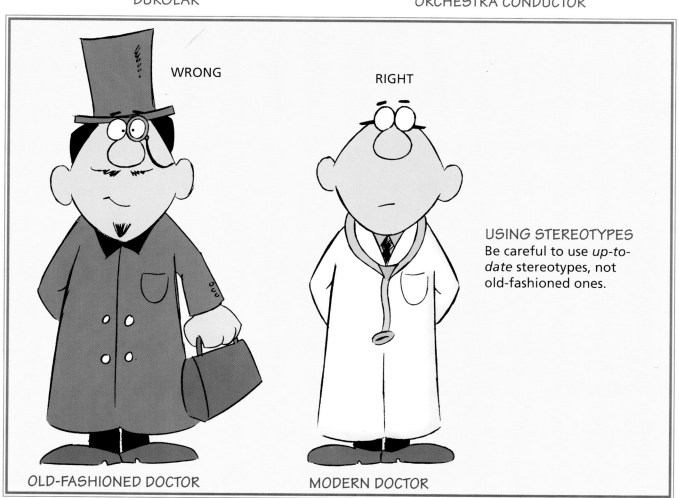

WRONG

RIGHT

OLD-FASHIONED DOCTOR

MODERN DOCTOR

USING STEREOTYPES
Be careful to use *up-to-date* stereotypes, not old-fashioned ones.

A Word about Style

You don't have to draw "cute." You can draw "weird." People like weird, as long as it's *funny* weird. The problem is that many new cartoonists, trying to carve out an identity for themselves, draw *ugly* weird. It's unpleasant to look at. Keep in mind that your readers have just woken up and are reading your cartoons over a bowl of corn flakes. They don't want to face anything unpalatable—the morning commute is going to be bad enough.

One way to create an edgy, yet funny, style is to push the cartoon past the normal bounds of exaggeration—to *over-exaggerate,* in some respects. Consider the drawing here.

Note: If your characters are stylized, your backgrounds should be stylized as well. Here, the strange overhead light and oddly shaped file cabinet add to the quirky feel of the illustration.

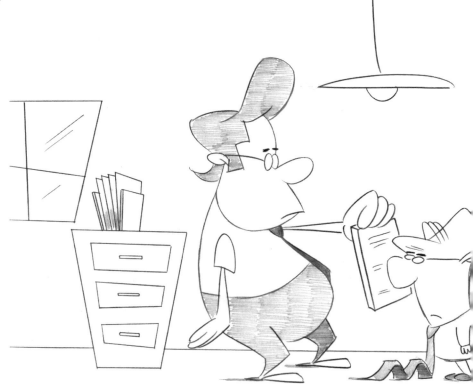

EDGY STYLE

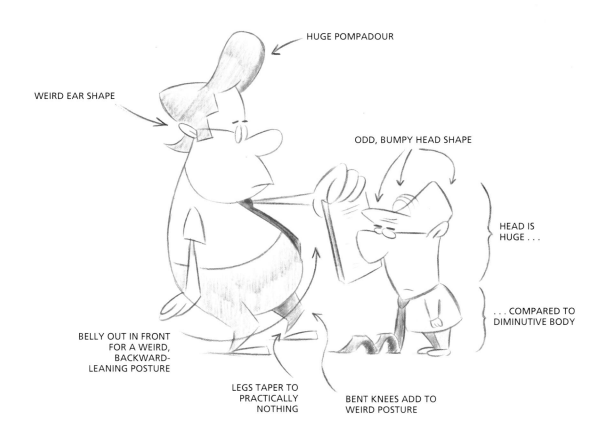

HUGE POMPADOUR

WEIRD EAR SHAPE

ODD, BUMPY HEAD SHAPE

HEAD IS HUGE . . .

. . . COMPARED TO DIMINUTIVE BODY

BELLY OUT IN FRONT FOR A WEIRD, BACKWARD-LEANING POSTURE

LEGS TAPER TO PRACTICALLY NOTHING

BENT KNEES ADD TO WEIRD POSTURE

Drawing Funny Animals

When it comes to animal anatomy, realism isn't funny. The further you go from reality, the funnier the "illo" (cartoonist's term for "illustration") will be. All of the canines here are appealing, but the zaniest, wackiest version is the one that is the least literal interpretation of a dog.

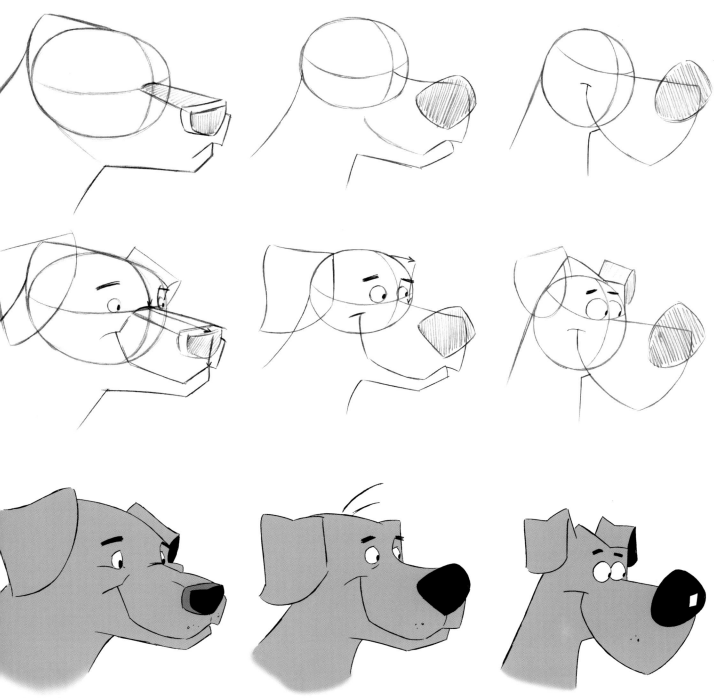

APPEALING
This is the most realistic version.

FUNNIER
Here's a cartoonier drawing of the realistic dog.

FUNNIEST
This, the least literal version, is definitely the most humorous.

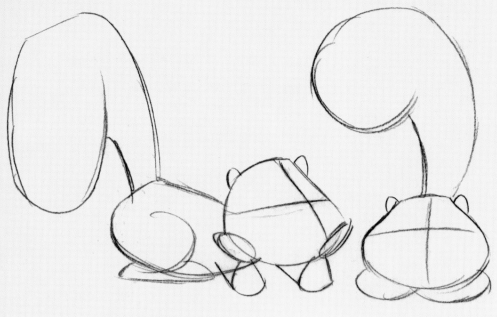

With animals, go for fat fingertips, big noses, and puffy tails. Think *plush toy.* Because, I can guarantee you that the executives at the comic strip newspaper syndicate are thinking *plush toy.* These guys dream about merchandise. But even if you're not such a venal, capitalist pig (c'mon, you know you are), a chunky look is vastly appealing. It turns feral creatures into warm, fuzzy play things.

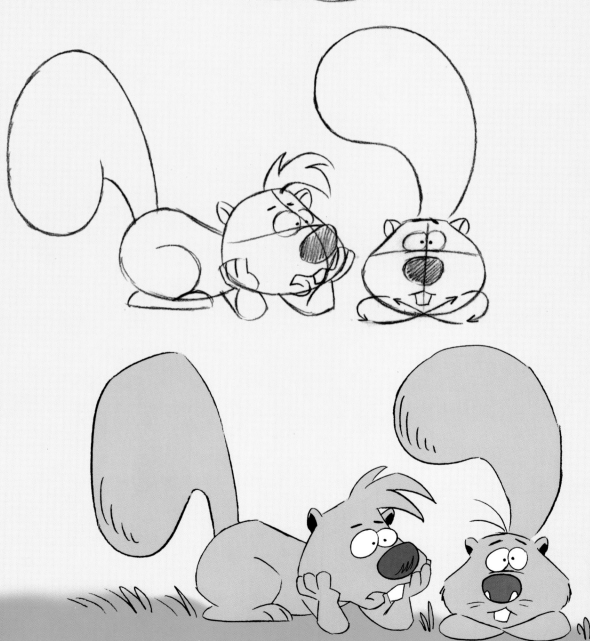

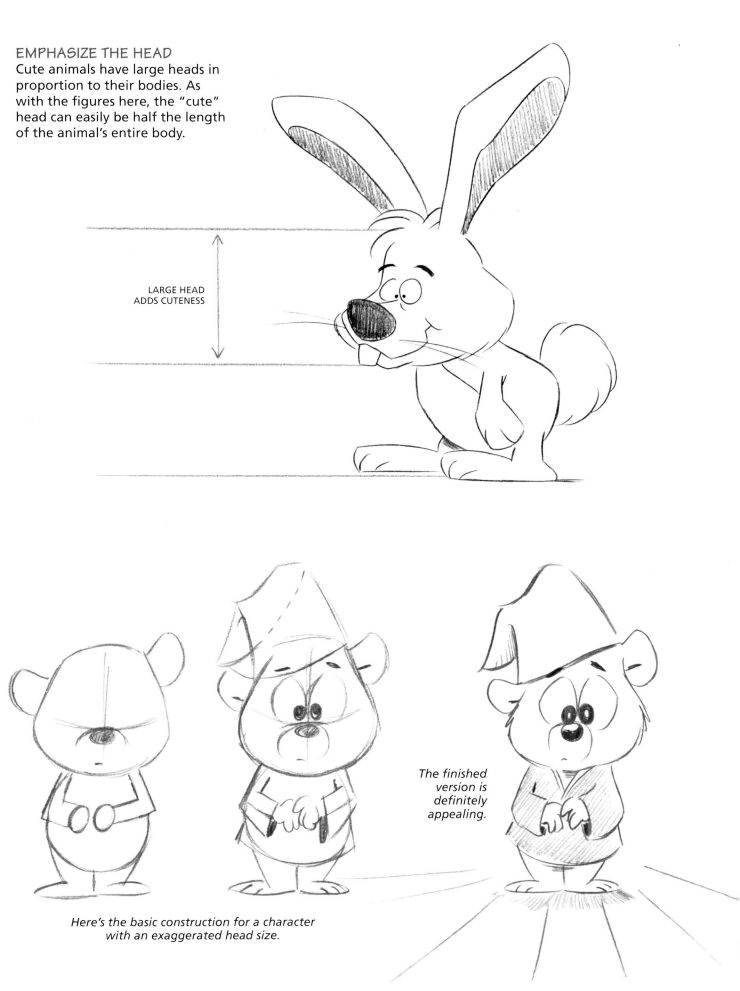

EMPHASIZE THE HEAD

Cute animals have large heads in proportion to their bodies. As with the figures here, the "cute" head can easily be half the length of the animal's entire body.

LARGE HEAD
ADDS CUTENESS

The finished version is definitely appealing.

Here's the basic construction for a character with an exaggerated head size.

What to Exaggerate

When drawing animals, focus on the first features that come to mind when thinking of each particular species. Of course, if I were to blurt out the word "alligator" and you were my wife, you'd blurt back, "Gucci hand bag." So, the experiment doesn't always work. However, if you're thinking more along cartooning lines, you'd probably think of an alligator's long, toothy snout, extended tail, and small limbs. Those features alone would be enough to produce a funny alligator.

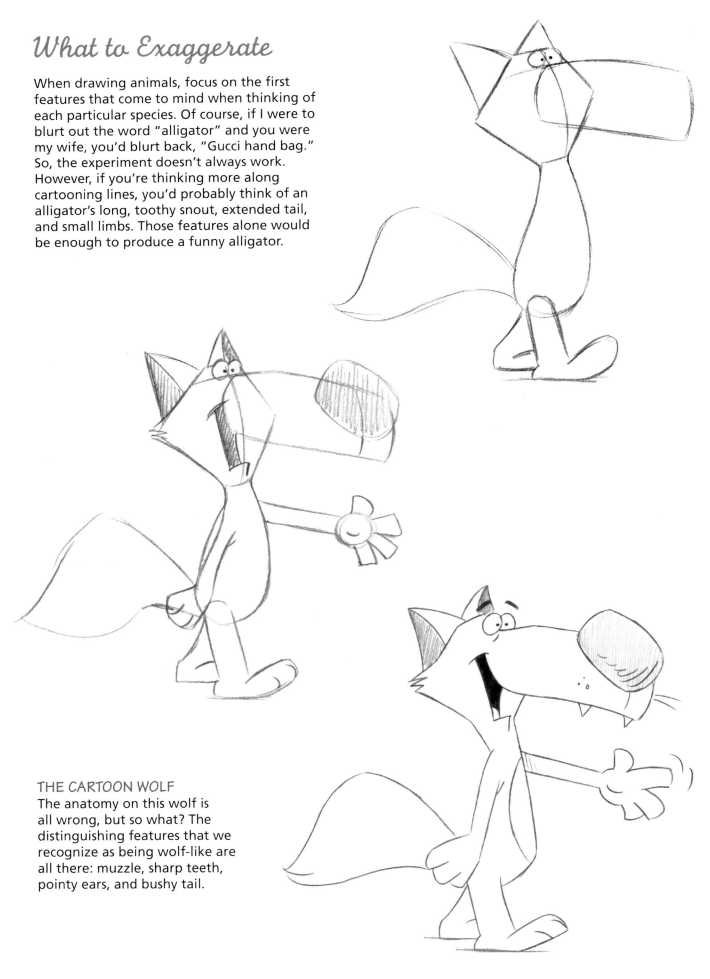

THE CARTOON WOLF

The anatomy on this wolf is all wrong, but so what? The distinguishing features that we recognize as being wolf-like are all there: muzzle, sharp teeth, pointy ears, and bushy tail.

ZANY RABBITS

A rabbit wouldn't be a rabbit without its cotton tail, huge ears, buck teeth, floppy feet, and some whiskers. All readers expect to see these things on rabbits, so make everybody happy and include them. Then, once you use those undeniably rabbit-like qualities, you'll be free to experiment with the rest of the creature and it will still read as a rabbit—no matter how outlandishly you design it.

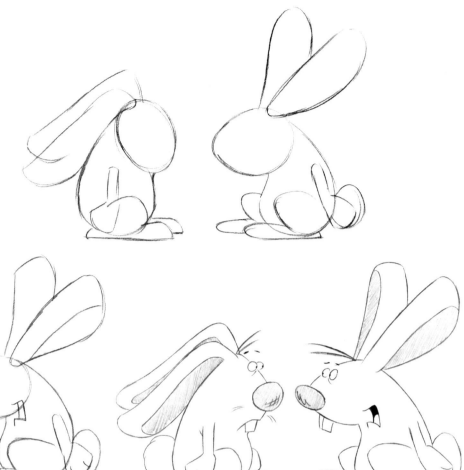

A FEW POINTERS FOR DRAWING BIRDS

The most important thing to remember about designing a bird's body is that the torso doesn't stand upright (with the exception of a penguin). It tilts forward at a 45-degree angle. Small birds, such as bluebirds and robins, have no necks—at least for cartooning purposes. Just stick the head directly on the body. Larger birds, such as ducks, geese, and turkeys, have long, thin necks like the one here.

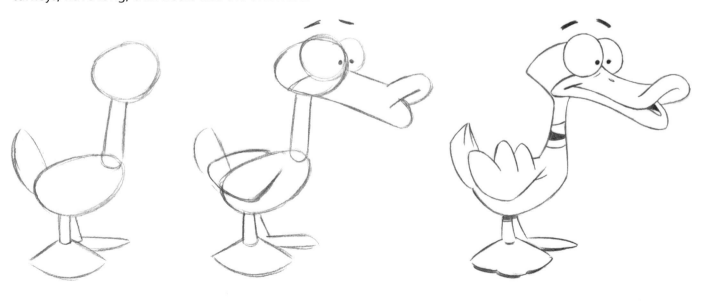

Turning Animal Anatomy into Cartoon Anatomy

With animals, the personality of the character should dictate the type of anatomy you choose. If you want to invent a funny, wise-guy tiger, don't draw the animal on all fours—it will look like a predator. Instead, stand the character upright, with human posture, so that it will appear less threatening. Before examining the different postures, however, let's take a look at some basic animal anatomy.

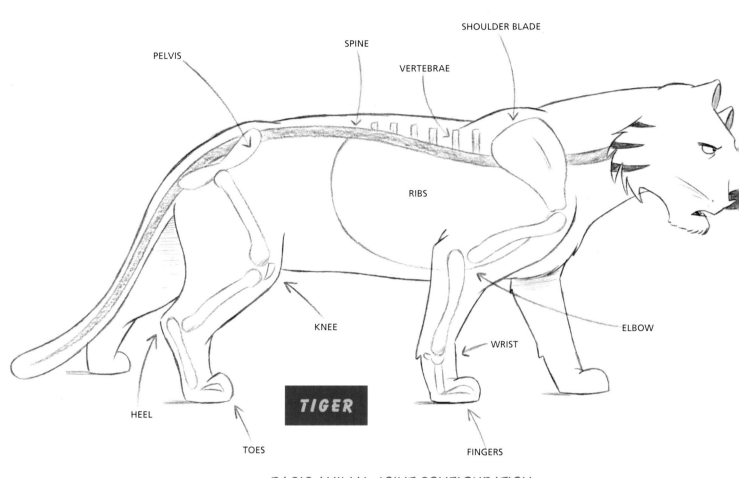

PELVIS

SPINE

VERTEBRAE

SHOULDER BLADE

RIBS

KNEE

ELBOW

WRIST

HEEL

TOES

TIGER

FINGERS

BASIC ANIMAL JOINT CONFIGURATION

I find it fascinating to look beneath the fur and muscles of an animal to see its skeleton, although you've got to do it pretty quickly, because the animal screams like hell. As a cartoonist, you're going to draw plenty of animals—count on it. You've got to know the actual anatomical construction of an animal in order to exaggerate it. It's easy to spot the work of a cartoonist who doesn't have a basic understanding of animal anatomy; the drawings lack conviction. The artist is groping, and the work looks amateurish.

There's also the possibility that at some point you'll need to draw a realistic looking animal or, at least, one that walks like a real animal. In that case, you'd better have an understanding of joint configuration. In the diagram above I've labeled all the major anatomical components in basic terms that correspond to human anatomy. In several places, I've simplified things, making two bones into one, since the double bones are side by side anyway and would only complicate the illustration. This basic skeleton is primarily the same for dogs, cats, lions, and horses.

EXCEPTIONS TO BASIC ANIMAL ANATOMY

Just when you thought you had it down, I throw you a curve. Hey, they never said I'd win any popularity contests teaching humorous illustration and joke writing. All they promised me was the toughest job in the world, enough to eat, and a feeling of pride at the end of the day. No wait— that was the army. Never mind. Anyway, it's important to note that while the tiger, horse, cat, and dog all have rear legs that appear to bend the wrong way at the knee (actually, their knees bend the same way as ours, but their rear feet are so long that they walk on their toes with their *heels* in the air), the bear and the elephant have rear legs that visually mirror ours when they bend.

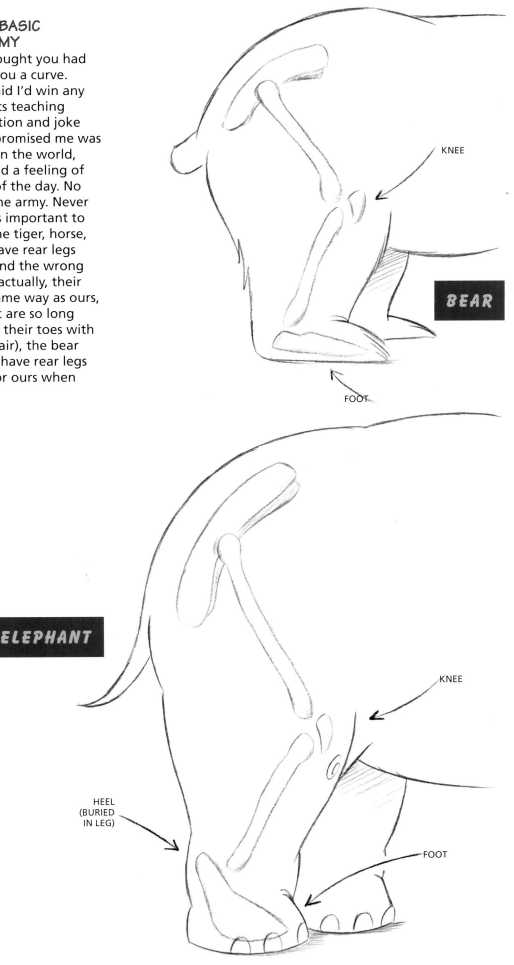

KNEE

BEAR

FOOT

ELEPHANT

KNEE

HEEL
(BURIED
IN LEG)

FOOT

FOUR BASIC BODY TYPES FOR QUADRUPEDS

A quadruped is an animal that walks on all fours, such as a dog, cat, or tiger. Many of the animals you'll want to draw will be quadrupeds, and there are a few different postures you can choose for them. I refer to these as the basic body types for quadrupeds.

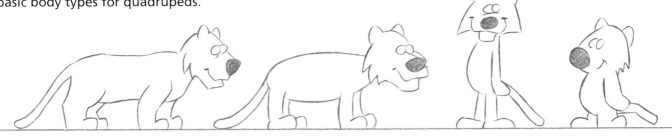

ON ALL FOURS—LOOSELY REALISTIC ON ALL FOURS—SIMPLIFIED UPRIGHT—LANKY UPRIGHT—COMPACT

ENHANCING THE HUMOROUS EFFECT

In reality, the shoulder is wider than the wrist, and the thigh is wider than the ankle. Reversing these proportions, however, produces an amusing effect. This is a popular technique used by cartoonists to enhance the humor of a character. Readers won't notice what's funnier about the character, but they'll react to the overall funny look, which is actually based on many conscious choices on the part of the cartoonist.

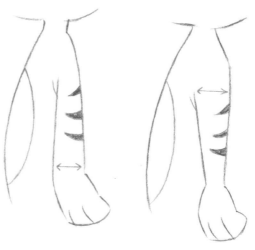

FUNNY NOT FUNNY

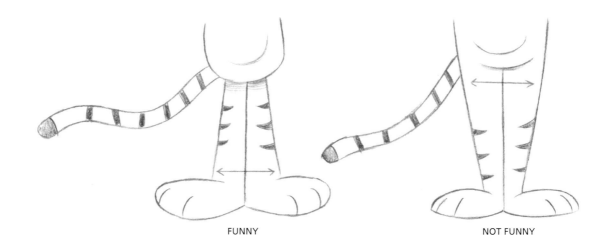

FUNNY NOT FUNNY

At the beginning of this section with the skeletons and everything, you thought I was trying to turn you into a zoologist. Now we're having fun again, and you're a little wiser from the experience. (Not that there's anything wrong with being a zoologist. I, for one, would not want to live in a world in which no one studied what different animals ate.)

When drawing animal characters you can go one of two ways; you can create more realistic looking animals, or you can simplify the animal form. Both methods can yield humorous results. Here, I use both techniques on the four-legged animal body.

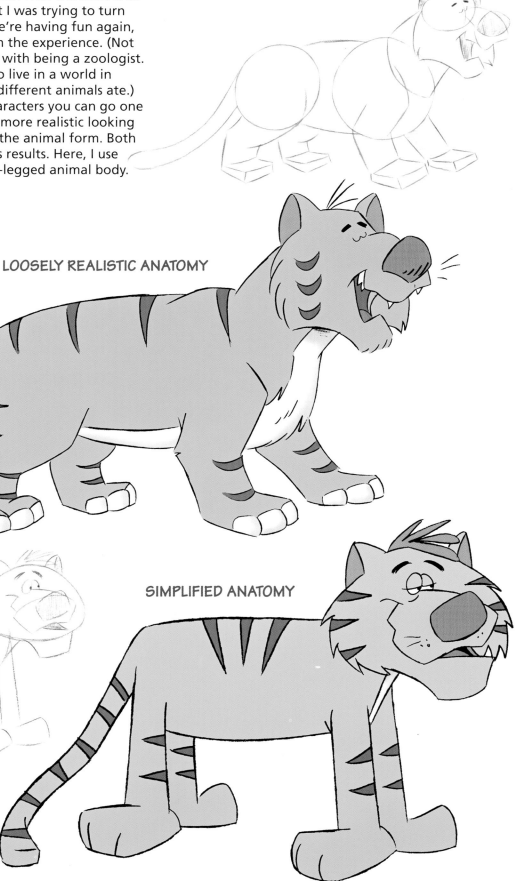

LOOSELY REALISTIC ANATOMY

SIMPLIFIED ANATOMY

Upright Animal Bodies

As with the quadruped animal character, the upright animal body type can also be represented in different ways, both to humorous effect.

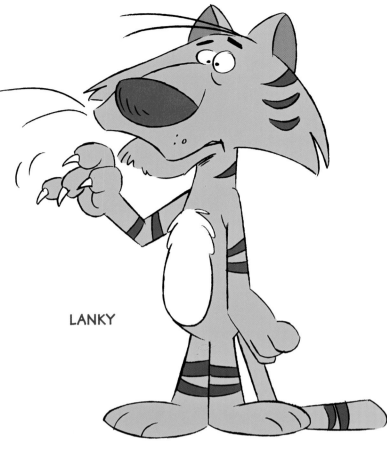

LANKY

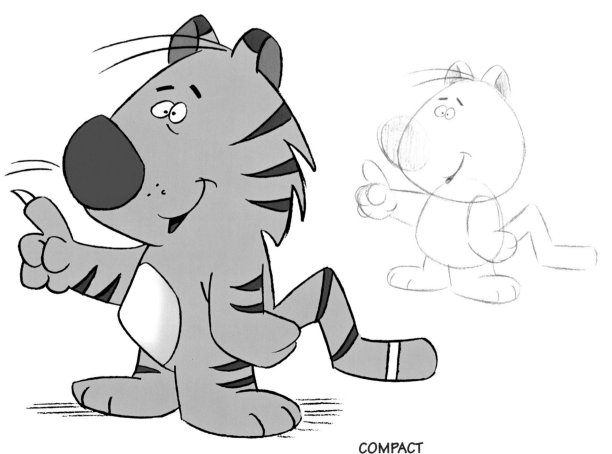

COMPACT

A comedy team is a pair of characters who play off of each other. Typically, one of them is funny, while the other is the straight man. And, they are easily identifiable as one or the other. For example, if you've ever watched the immortal routine *Who's on First?* by Abbot and Costello, you have no question as to who the straight man is. There's also no doubt that without Abbot's purposeful and even delivery, Costello would be all over the place. The straight man prevents the humor from veering off track.

The physical appearance and size of each player in the comedy team must contrast with that of the other. Some classic examples are: Ralph Kramden (fat) and Ed Norton (thin); Fred Flintstone (tall) and Barney Rubble (short); Beetle Bailey (thin) and Sarge (fat). Comedy teams are especially popular in comic strips. The most important thing to remember in designing a team is that there must be friction; whether the characters are friends or not, they've got to rub each other the wrong way. That's when the sparks fly. Referring back to Abbot and Costello again, Costello becomes more and more annoyed with Abbot as the routine progresses.This annoyance factor is the glue that bonds them together.

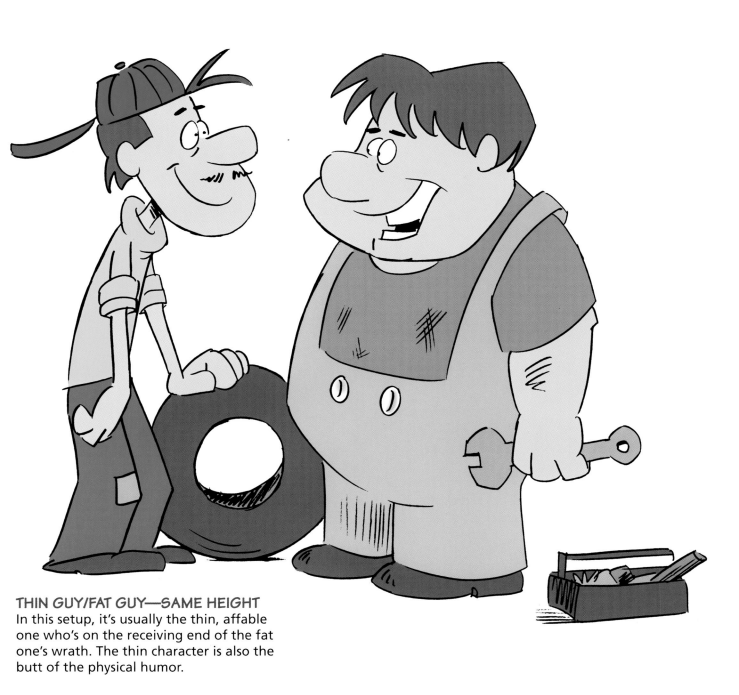

THIN GUY/FAT GUY—SAME HEIGHT
In this setup, it's usually the thin, affable one who's on the receiving end of the fat one's wrath. The thin character is also the butt of the physical humor.

THIN GUY/FAT GUY—DIFFERENT HEIGHTS

This is an explosive comedy team. Usually the tiny, fat guy is the powder-keg personality, ready to blow his stack at a moment's notice. He's often cast as the boss. The tall, thin guy is a beat behind, oblivious until he's chewed out by his boss.

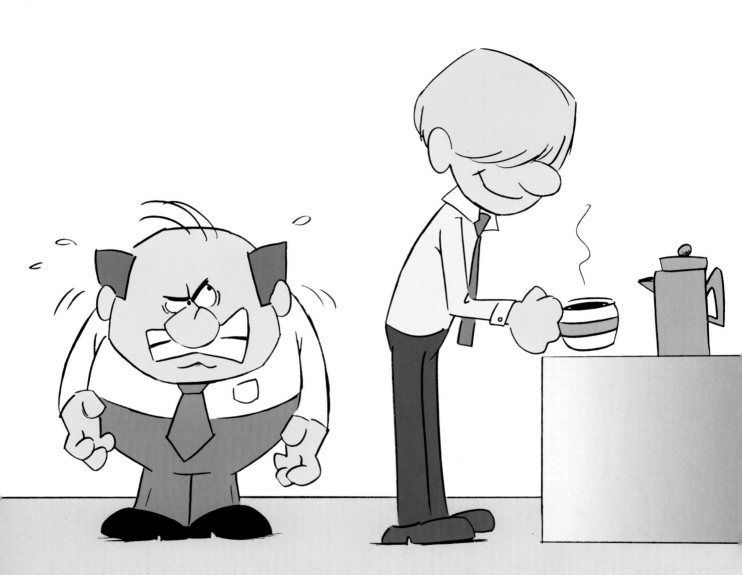

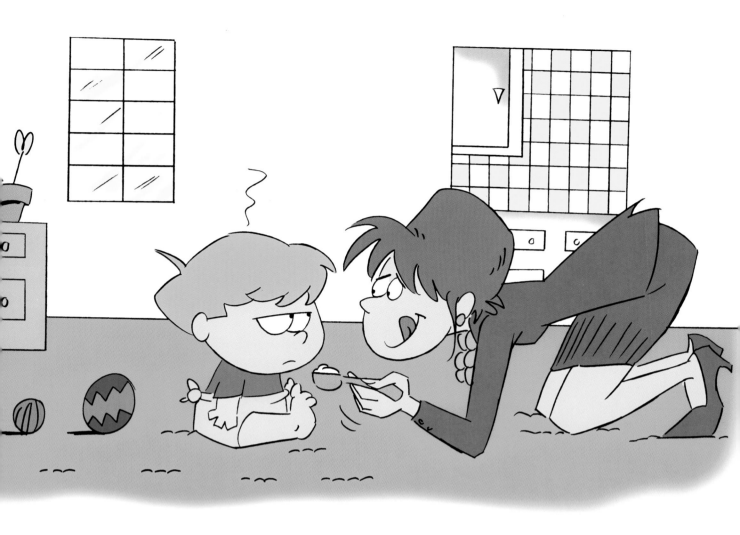

ADULT AND BABY

I never was a fan of this setup, but audiences love watching babies who are smarter than their parents. People also like watching funny nuns, so there's no accounting for taste. (Hey, how about a funny baby who thinks she's a nun?) Anyway, in this setup, there's a huge disparity in size between the characters, which immediately sets up the physical humor. There's also the problem of feeding, changing, and reigning in the baby, so there's a lot of material with which to work. Focus on giving your character an attitude; if all you do is make the baby smart, it'll be dull. The baby also has to have an attitude—usually a cynical one. And, don't make the grown-ups too dumb; your average adult is dumb enough.

If this comedy team scenario tickles part of your brain, you're not alone; many popular comic strips, feature films, and animated shows have starred babies imbued with extraordinary intelligence. It's this "tickle" that drives creativity in humor. If you don't have it when you start a project, then whatever else you think you do have—whether it's timeliness or marketability—isn't enough. Drop it and move on to something else. Also keep in mind that all your ideas are abstractions until you put them down on paper. You may look at a concept and say, "It's not as funny as I thought." On the other hand, you might say, "I think this *is* funny, no matter what Chris Hart, or my neighbor, or the guy who makes change at the arcade says!" Guys like you scare me.

Cartoon Comedy Teams—Animals

You thought only humans could make up comedy teams? *Au contraire*, pal. Animals make great comedy teams. One animal is usually cast as stupid, the other smart. One is the leader, the other the follower.

NATURAL ANTAGONISTS

Animals that are natural antagonists, such as dogs and cats, make excellent comedy teams in animation as well as in comic strips. The friction is instinctive—you don't have to go looking for it. Another factor is proximity. It's best if you have the two animals living close together, preferably in the same house. Closeness breeds contempt, and that breeds humor.

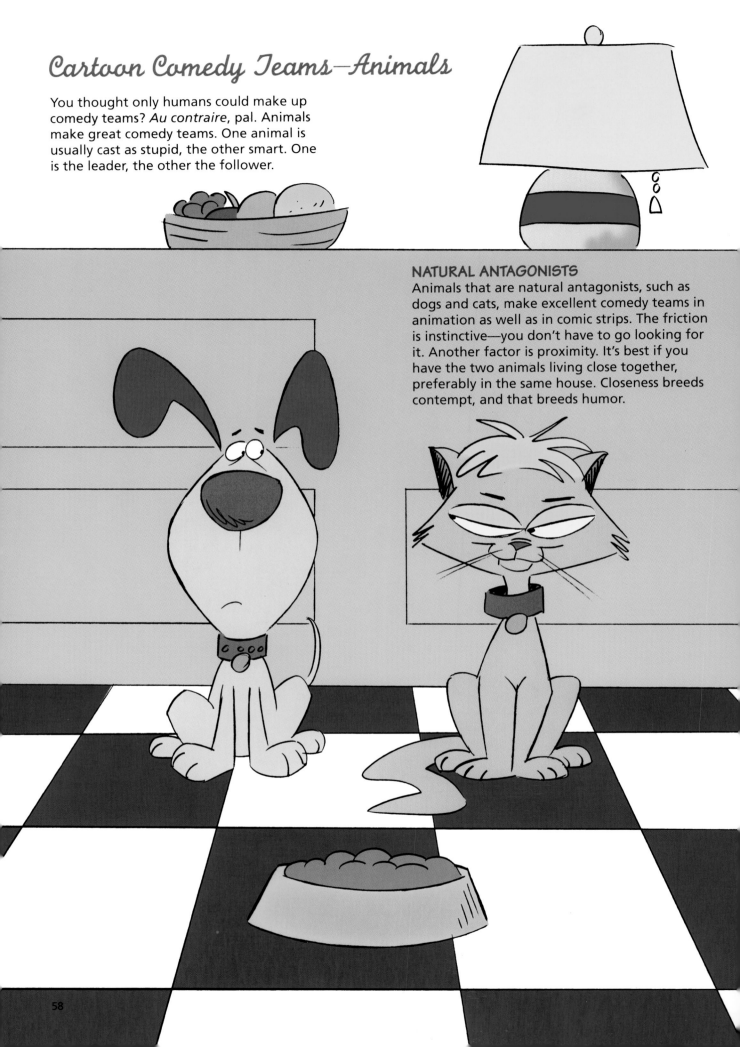

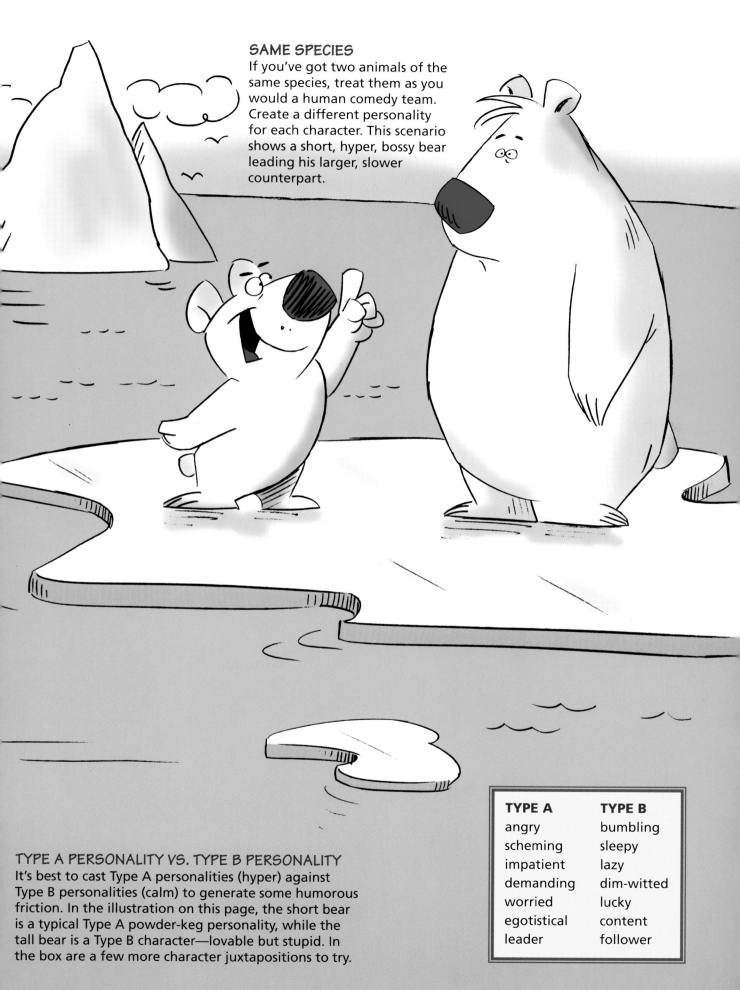

SAME SPECIES
If you've got two animals of the same species, treat them as you would a human comedy team. Create a different personality for each character. This scenario shows a short, hyper, bossy bear leading his larger, slower counterpart.

TYPE A PERSONALITY VS. TYPE B PERSONALITY
It's best to cast Type A personalities (hyper) against Type B personalities (calm) to generate some humorous friction. In the illustration on this page, the short bear is a typical Type A powder-keg personality, while the tall bear is a Type B character—lovable but stupid. In the box are a few more character juxtapositions to try.

TYPE A	TYPE B
angry	bumbling
scheming	sleepy
impatient	lazy
demanding	dim-witted
worried	lucky
egotistical	content
leader	follower

Cartoon Comedy Teams—Animals with People

The animal/person comedy team is usually comprised of the pet owner and the pet. The size of the animal, as compared to its human counterpart, will dictate its personality type.

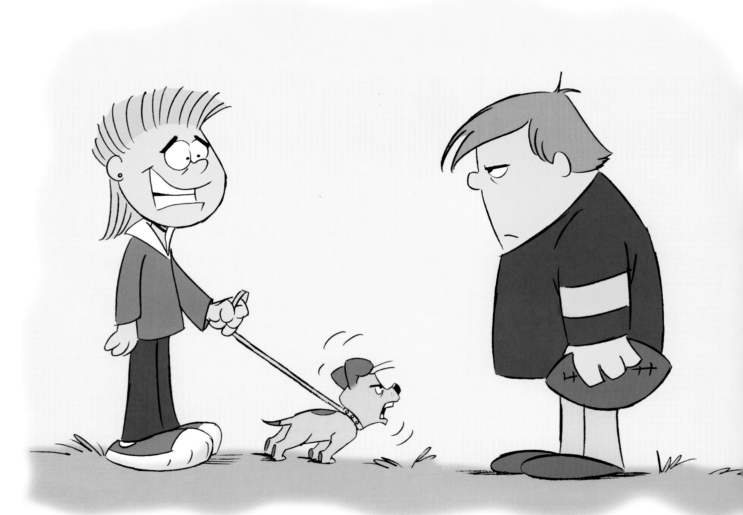

THE SMALL PET
This adorable tyke always gets his master into trouble but never suffers any of the consequences himself. He's happy and ditsy but can also be cast as a nervous runt.

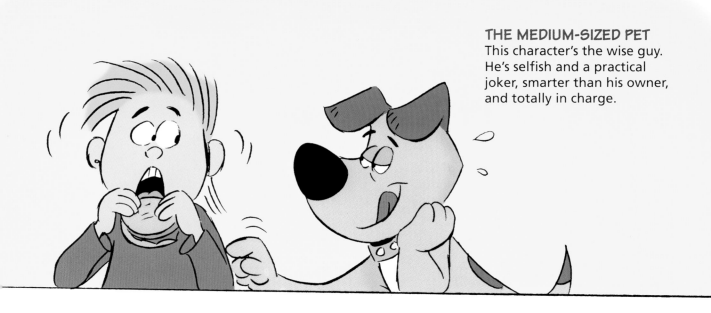

THE MEDIUM-SIZED PET
This character's the wise guy. He's selfish and a practical joker, smarter than his owner, and totally in charge.

THE LARGE PET
This good-natured oaf doesn't know his own strength. He's friendly, awkward, and dumb.

Give Your Characters Something to Do

I can't think of anything duller than two characters just standing in the middle of a comic strip panel talking to each other. Well, maybe I can think of one thing—cello lessons. Anyway, any action is going to be more interesting than a static scene. However, I don't mean action that's so bold it draws attention away from the dialogue. It should be the type of action that goes on *while* the characters are talking. It takes a back seat to the dialogue.

It must be said, though, that some very funny scenes have been drawn with just "talking heads," as they're called. But if that's all your comic strip shows, week in and week out, your audience will soon stop looking at the pictures and just read the words. And then you're only running on two pistons.

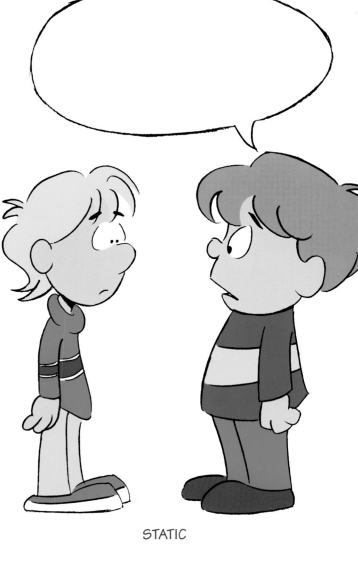

STATIC

ACTIVE

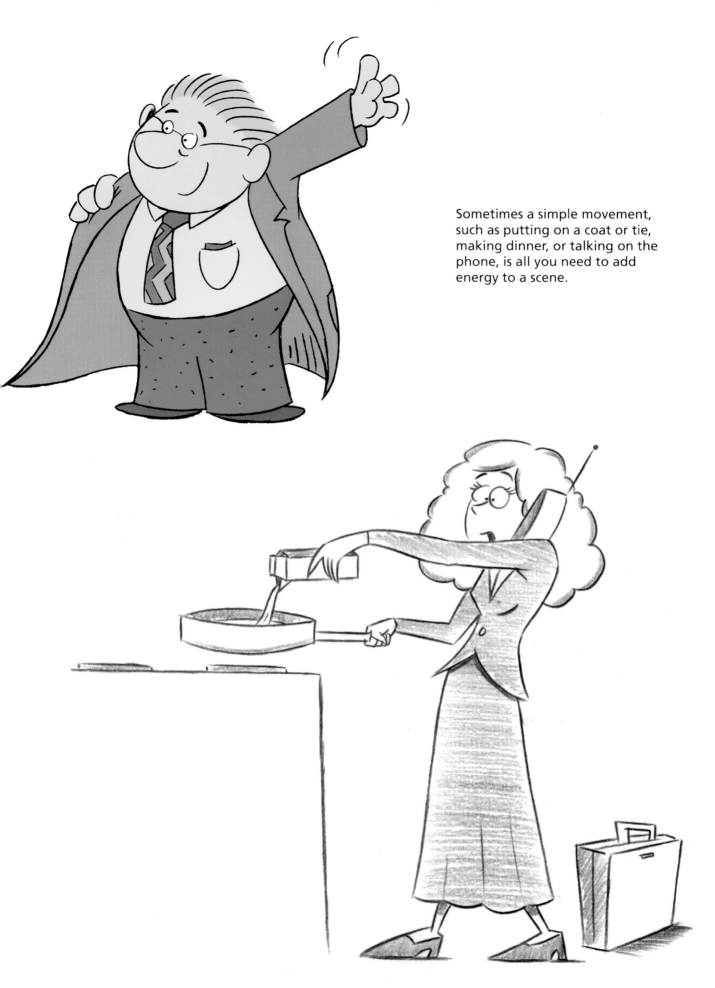

Sometimes a simple movement, such as putting on a coat or tie, making dinner, or talking on the phone, is all you need to add energy to a scene.

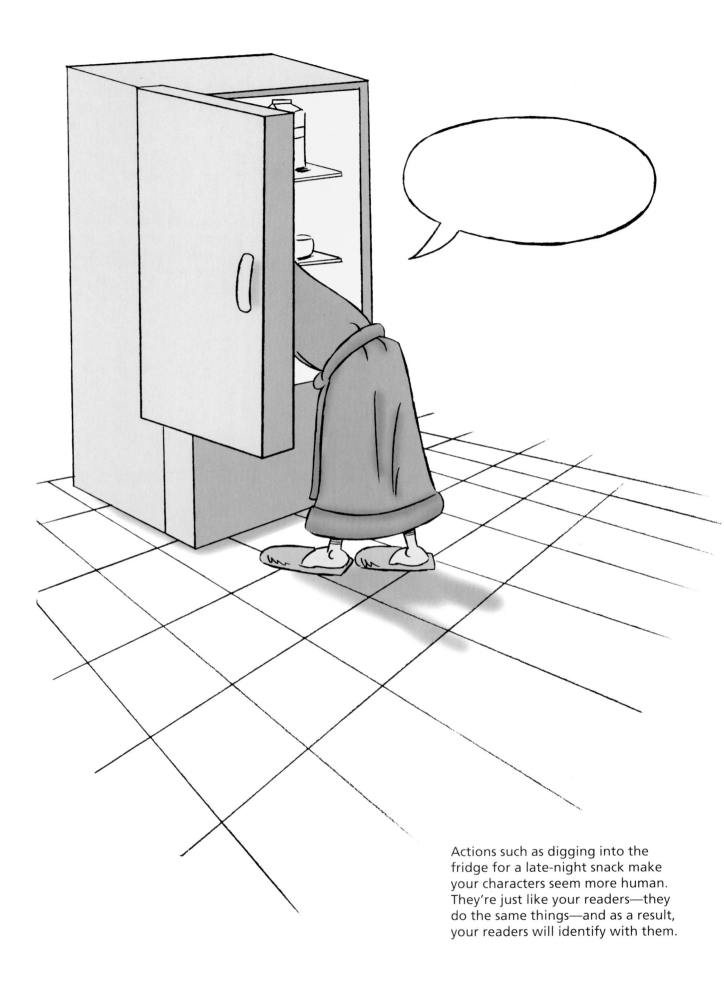

Actions such as digging into the fridge for a late-night snack make your characters seem more human. They're just like your readers—they do the same things—and as a result, your readers will identify with them.

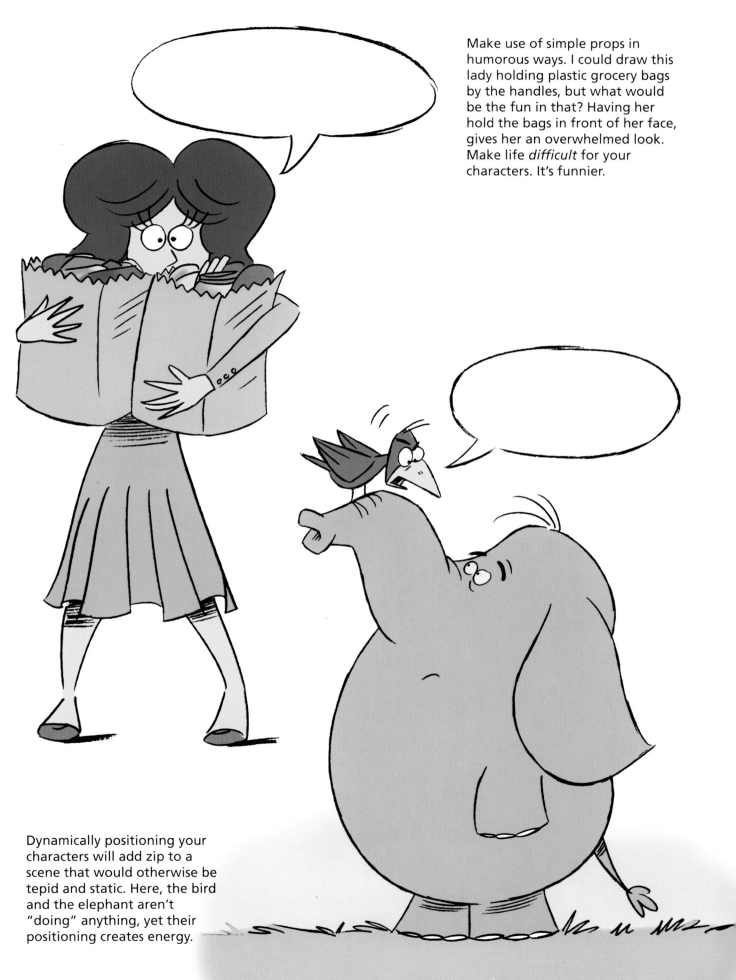

Make use of simple props in humorous ways. I could draw this lady holding plastic grocery bags by the handles, but what would be the fun in that? Having her hold the bags in front of her face, gives her an overwhelmed look. Make life *difficult* for your characters. It's funnier.

Dynamically positioning your characters will add zip to a scene that would otherwise be tepid and static. Here, the bird and the elephant aren't "doing" anything, yet their positioning creates energy.

WRITING JOKES

I'm not going to dissect humor in this chapter. Anyone who asks the question, "What is humor?" isn't funny. Trust me on this. I had a professor in college who taught a course in film comedy. In my opinion, he was the dullest man in the history of the world. Thought I was going to die midway through each lecture. This guy spent all of his pitiful waking hours trying to explain humor. Can't be done. Want to know why? Okay, here's my treatise on what humor is: If something's funny. That's it. That's the complete answer. We're done.

So, I'm not going to talk about humor, but I am going to talk about jokes— about how to craft them and how to make them pay off—because, unlike humor, joke structure is a skill that can be taught. And, here's a valuable piece of advice: Never take a course on film comedy from a guy who laughs out loud at Buster Keaton.

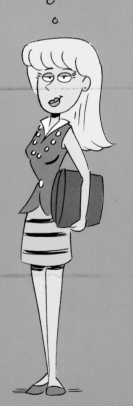

AMBITIOUS CAREER WOMAN LOVESTRUCK TEENAG

Generally, it's easier to write about people your own age and younger, because *you've been there.* This doesn't mean that if you're a teenager, you must only write about teenage things. However, you'd have an advantage if you approached your subject from an angle that's familiar to you. You could write a comic strip about parents raising kids, but you'd have a better slant if you wrote from the kid's point of view, rather than that of the parents.

You can also write about anything with which you're obsessed. If you've never known a lawyer in your life, you could still write about lawyers if you've watched just about every courtroom drama on television. You could write about sports even if you're the spitting image of the Pillsbury Dough Boy, as long as you sit in front of the tube all weekend watching other people sweat. Here are a few other subject ideas:

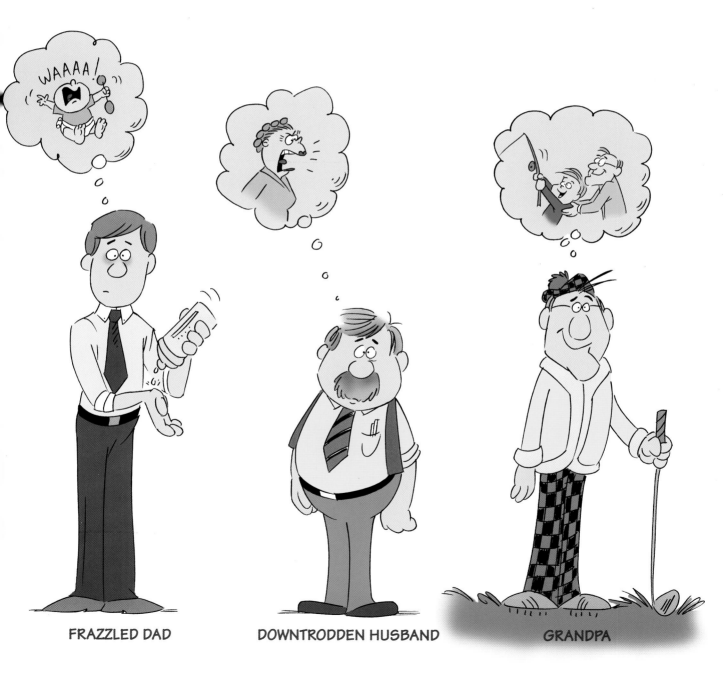

FRAZZLED DAD DOWNTRODDEN HUSBAND GRANDPA

Which Comes First—The Drawing or the Joke?

The joke. You thought it would be more complicated than that? Sorry. It's the joke. You were hoping, maybe, that it was the drawing? Nope. The joke *always* comes first. It's just not possible to craft a funny joke based on a few randomly drawn panels. The artist won't have a single visual idea until the writer comes up with the premise for the joke.

Suppose you have a four-panel comic strip with two interacting characters. What are you going to do? Draw two heads talking for four panels? What a scream that would be. However, if you *know* what the characters are talking about, you can add props and backgrounds, and choose angles that underscore the point of the scene. There are, of course, a few exceptions. I know, I made it sound like there weren't any exceptions, but I was just trying to make a point. Single-panel strips, especially weird ones, can be inspired by a funny image. Sometimes, a funny image can inspire an idea for a multiple-panel gag, but the multiple-panel gag must still be written out panel by panel before the actual art is drawn.

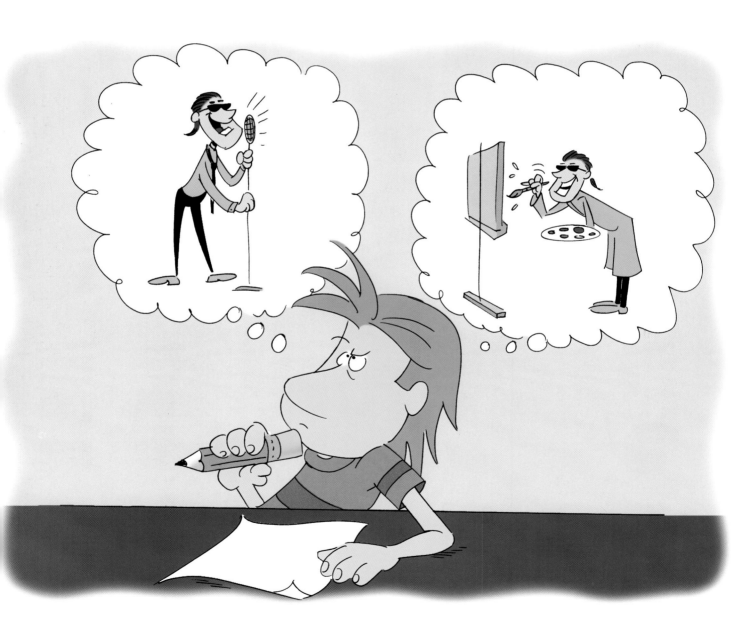

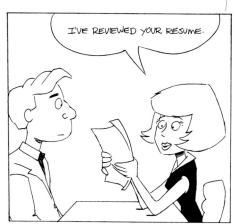

From Script to Strip

Cartoonists and gag writers often allow an idea to percolate in their heads. Then, once it's ready, they jot it down on a pad. The next step is to lay the joke out panel by panel for the artist to illustrate. Even if you're both the writer and artist for your strip, it's a good idea to lay everything out. You might find, for example, that a speech balloon in panel two works better in panel three. It's also extremely important to make interesting cuts between panels, and this may entail choosing different background locations. Be sure that you also think in terms of who is *on panel* and who is *off panel* in the strip. You don't need to show everyone all the time. Here's the general evolutionary process:

Above is the rough gag. None of the description needs to be included; you're just recording the joke at this stage.

```
GAG # 1

PANEL 1:  A GUY IS BEING INTERVIEWED FOR A JOB.  THE LADY GIVING
THE INTERVIEW IS ATTRACTIVE, LATE TWENTIES/EARLY THIRTIES.  A
PROFESSIONAL.  SHE IS LOOKING AT HIS RESUME AS SHE SITS ACROSS
HER DESK FROM HIM.

LADY INTERVIEWER:  "I've reviewed your resume."

PANEL 2: SHE PUTS THE RESUME DOWN, INTERLACES HER FINGERS, AND
POSES A QUESTION.

LADY INTERVIEWER:  "But before we continue, I'd like to know if
you have any problem with a woman boss?

PANEL 3:  SAME.

MAN BEING INTERVIEWED:  "Not if she's as good looking as you
are."

PANEL 4: MAN IS NOW STANDING OUTSIDE, IN FRONT OF THE OFFICE
BUILDING, WAITING AT THE BUS STOP.  BY HIS EXPRESSION, WE SEE
THAT HE OBVIOUSLY DIDN'T LAND IT.  HIS THOUGHT BALLOON READS:

MAN'S THOUGHT BALLOON:  "I've got to rework that resume."
```

Next comes the panel-by-panel description. For this you script the joke out as you envision it, panel by panel, being careful not to crowd too much dialogue into any one panel.

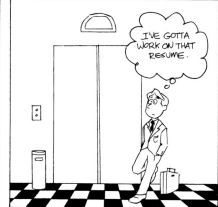

In the final inked version, some changes have been made since the previous step. The final location of the last panel is different, and some of the dialogue has been streamlined.

Testing Out Your Material

You should always test out your jokes prior to committing them to your strip. You're going to need someone you feel comfortable annoying with your material. It can be anybody, so long as it's not me. Actually, it can be *almost* anybody. There are two people it can't be. The first is your mom, because she'll think everything you tell her is brilliant; so, unless she's the head of a comic strip syndicate, look elsewhere for input. The second person is another professional cartoonist. Jealousies, subconscious or not, may cloud his or her judgment. You want a closemouthed friend—someone with an *average* sense of humor, not someone who is a fan of yours. Comic strips reach a broad segment of society—the average person is your reader.

Get two sounding boards, in case you can't get a hold of one. This will also give each person a break now and then. I wouldn't get more than two testers, otherwise you might end up with four different opinions for each joke. It'll drive you nuts. In my experience, your testers will enjoy and look forward to this break in their day, and your mother will forgive you for going elsewhere for opinions.

Save up your gags and unload them on your testers all at one time, perhaps once every one or two weeks. This way, they'll feel that they can be honest with you and say when they don't like a joke, since they'll be hearing enough gags that they do like. When testing out your jokes, also remember to use your own judgment. It's *your* strip, not your friends'. If they don't like a gag, but you still feel strongly about it, maybe they're wrong. Another problem crops up when you've looked at a joke for the eighth time and suddenly realize that it's not funny anymore. Hey, if it was truly funny the first seven times, it should *still* be funny.

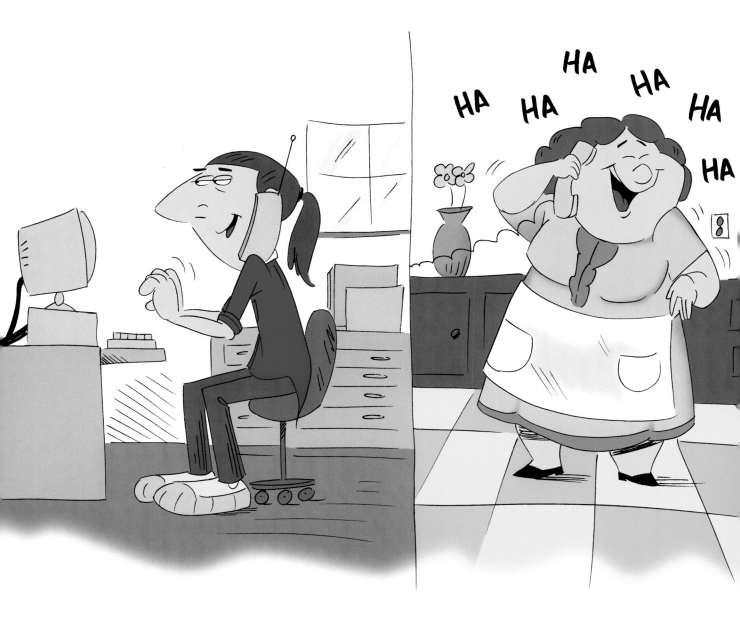

Of Cats, Babies, and Cavemen

Due to a popular cat comic strip called *Heathcliff,* no one thought another cat strip would make it into the papers. Then *Garfield* happened. *Alley-Oop* was a famous comic strip about a caveman, so everyone *knew* another comic strip about cavemen wouldn't make it. Then came *B. C.* Originally, *Marvin* captured the baby market. Then *Baby Blues* appeared.

Yes, it's harder to sell an idea if a similar one already exists in the marketplace. But, if you've got a new angle—a hipper angle—and you've invented what you believe is really a substantially better mousetrap, then go with it. Don't be dissuaded because someone else did it first.

Popular Comic Strip Genres

Your comic strip should fit into a genre like those listed here, otherwise, how will the syndicate's sales force be able to sell it to the newspaper editors, who think in sound bites? How's the salesperson going to present it? Note that I said "salesperson." A salesperson is going to be the one describing your strip to the buyers at the newspapers. If your work doesn't fit into a genre, the sales pitch might go something like this: "I've got a great new comic strip to show you. It's sort of about an animal, but there are people in it, too, with a family, but it's more about the animal, and it's set sometime in the future. I'm not sure exactly when." Not exactly a slam dunk, is it?

It would be far better if the pitch went like this: "I've got a great new family strip about an incorrigible teenage daughter." Now the newspaper editors know what they're looking at. Setting your comic strip firmly in a specific genre will give you *more* creative freedom, not less. Once you establish the boundaries of a genre, you can spend your energies poking fun at them. *The Wizard of Id* is a good example of this. It's firmly established as a medieval comic strip, with a knight, a maiden, a king, a wizard, a jester, castles, and the whole shebang, *but* it's constantly winking at its readers with modern-day jokes and references. Jokes work well only when there are boundaries, rules, and social norms to play against.

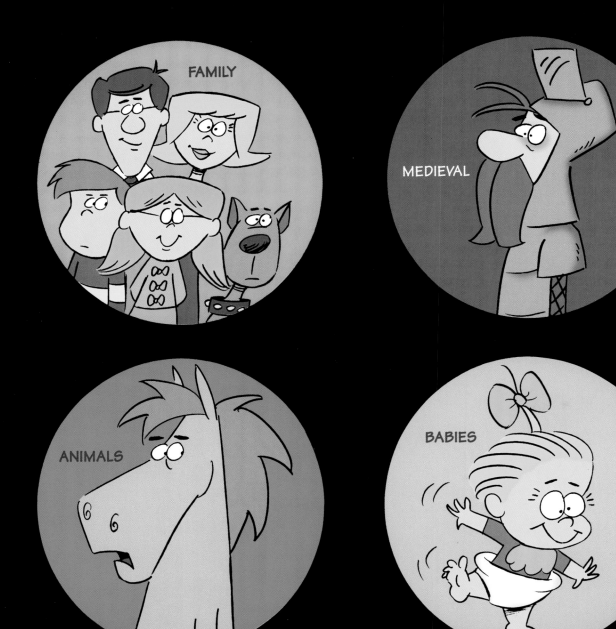

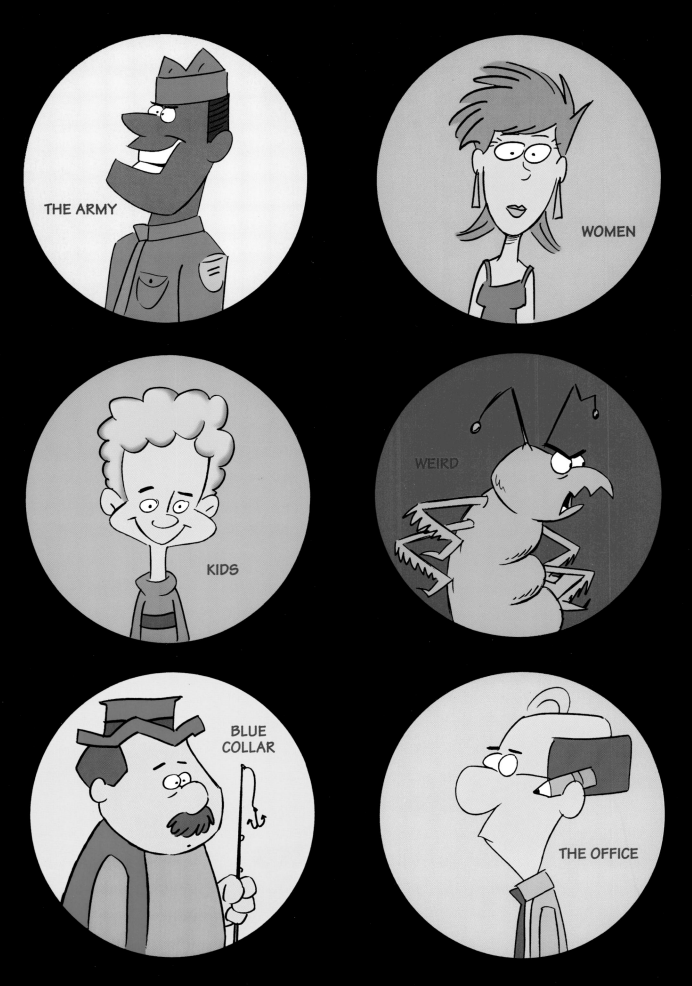

The All-Important "Hook"

Any good comic strip needs a *hook*—a humorous premise that draws readers in. You can create all the funny characters you want, but without a hook, your strip will never sustain itself. The hook should be a one- or two-sentence description of the premise. The best place to find good examples of hooks is in *TV Guide Magazine.* Read the descriptions of the sitcoms. Notice how brief they are, yet everything you need to know is there.

Here's an example of a hook that could launch a comic strip: A teenage girl from a typical middle-class family is always falling in love with guys her parents can't stand. If it takes much longer than that to explain it, you don't have the hook yet. The hook is the grabber. You can add the ancillary characters later.

"A divorced couple" is not a hook. It's an area. It has no angle, no sharp edge. Here's the hook: A divorced couple that works together in the same office. Now that's a hook! We see the situation. The complications immediately spring forth. If you're having trouble finding enough funny things about which to write, you may be working too hard. Your hook is underdeveloped.

"A confirmed bachelor" isn't a hook. This is the hook: A confirmed bachelor who's in a relationship with a woman who's only desire is to marry him.

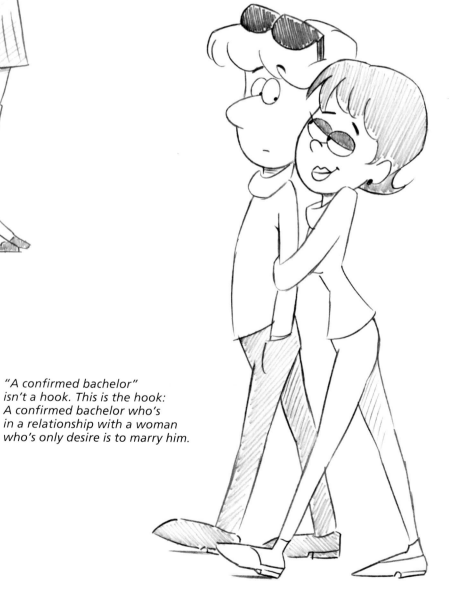

Conflict in Humor

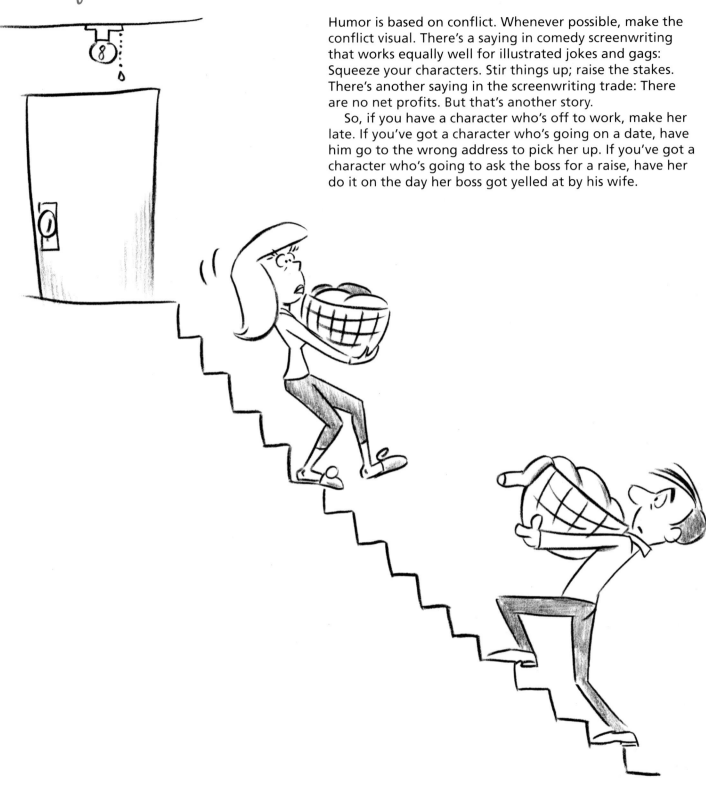

Humor is based on conflict. Whenever possible, make the conflict visual. There's a saying in comedy screenwriting that works equally well for illustrated jokes and gags: Squeeze your characters. Stir things up; raise the stakes. There's another saying in the screenwriting trade: There are no net profits. But that's another story.

So, if you have a character who's off to work, make her late. If you've got a character who's going on a date, have him go to the wrong address to pick her up. If you've got a character who's going to ask the boss for a raise, have her do it on the day her boss got yelled at by his wife.

Avoid Clichés

SHRINK JOKES

Some jokes that are based on clichés are funny. Still, the initial reaction of the reader will be, "Oh, another shrink joke." Some well-established comic strips can milk these areas forever because they've already attracted a loyal readership.

COURT JOKES

However, editors don't want to see the same old stuff when they scout for new talent. They want to be surprised, refreshed. They want what's new. So, in general, avoid the tired subjects illustrated here.

BAD-COOKING JOKES

MOTHER-IN-LAW JOKES

Mom!

Know Your Character's Agenda

Your characters each must have an agenda, and these agendas *must* be at cross-purposes. The *friction* creates the humor. What exactly is an agenda? It's basically the things your characters want but don't actually verbalize or admit to—they talk around them. Here are some examples of character agendas: to find a good relationship, to avoid work and goof off, to shop 'til they drop, to move up the corporate ladder.

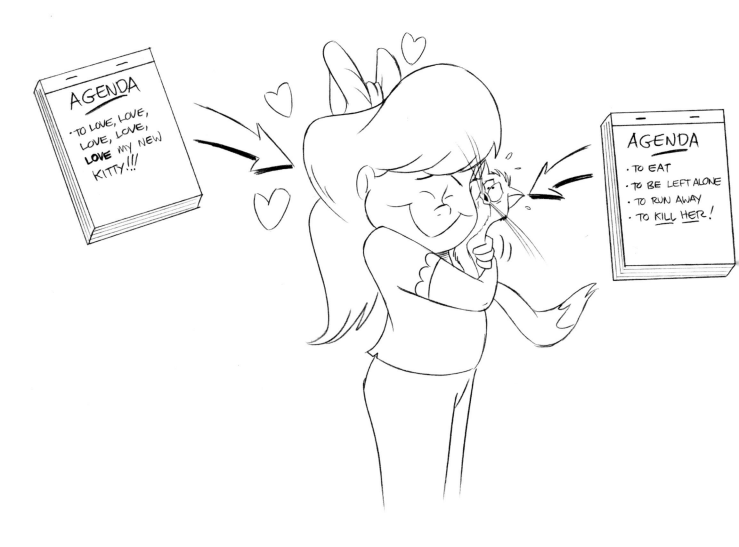

Look into the Future

When coming up with an original comic strip, you've got to ask yourself this question: What will I be writing about a year from now, or even ten years from now? You've got to ask that question because the editors at the syndicates will surely ask it before they sign you—and they'll expect good answers. They want assurance that you know how to keep your concept fresh for the long haul. For example, Can your premise sustain itself? How will your characters evolve? What new challenges will your characters face? What interesting new characters and situations are you thinking of introducing down the road?

This is why the syndicates demand so many samples of your strip before they agree to sign you. They want to know that you can produce, and that you didn't spend five years coming up with only two weeks worth of terrific dailies.

Assembling a Cast

All right. You've got your idea for a comic strip. What do you do next? Start assembling a cast. You've probably thought about the main characters and maybe one or two supporting characters. However, in order to create a world into which your readers can dive, you're going to have to weave together a few more players.

There are three types of characters: lead, supporting, and ancillary. Leads appear in almost every comic strip. Supporting characters appear less often, but regularly. Ancillary characters may not appear for weeks at a time, but must reoccur with enough frequency so that they won't be forgotten. Here's an example of a typical cast for an animal comic strip. Note that there are many more supporting and ancillary characters than there are leads. If you have too many lead characters, your strip will lose its focus. You must determine who the strip is about.

DOG—LEAD

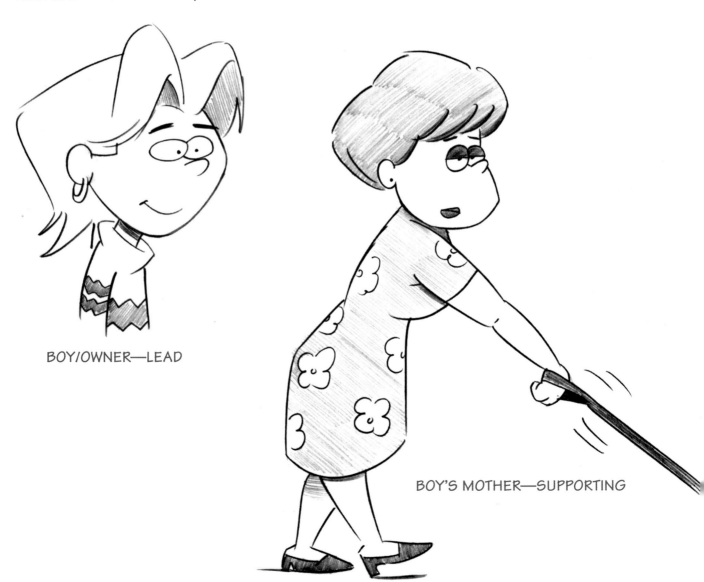

BOY/OWNER—LEAD

BOY'S MOTHER—SUPPORTING

SISTER—SUPPORTING

NEIGHBOR WHO HATES
BARKING—ANCILLARY

MAILMAN—ANCILLARY

NERVOUS NEIGHBORHOOD
CAT—ANCILLARY

The Setup Line: The Key to Writing Jokes

Everyone "knows" that a good punch line is the key to a funny joke, and everyone is *wrong.* The punch line is the easy part. It's the setup that's really the key. Given the right setup, anyone can think up a punch line.

When I was working with Dean Young, owner of the *Blondie* comic strip, he told me that his chief artist at the time was one of the funniest guys he knew. This guy would have him rolling at parties but wasn't as funny when it came to thinking up original jokes for the strip. To me, having written many of the *Blondie* gags myself, the reason was obvious. All the artist does is fill in the gap; the writer leaves a setup line dangling in the air, like a hanging curve ball, and the artist simply knocks it out of the park. There's no doubt that this artist was a funny guy, but he was probably *reacting* funny, not *creating* funny. To create jokes, you need to come up with the setup line.

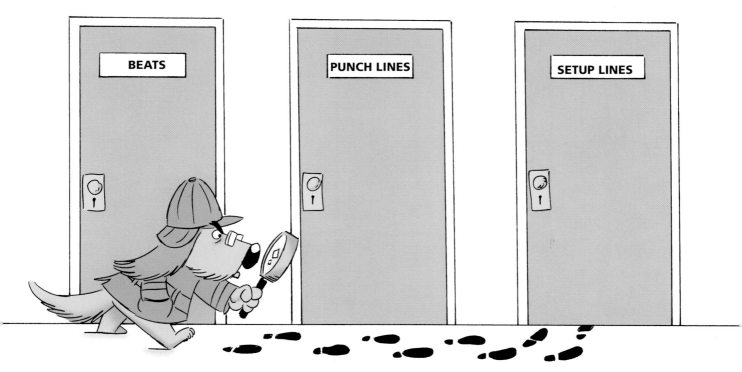

Hard Punch Lines vs. Soft Punch Lines

There are two basic types of punch lines: hard and soft. The *hard punch line* has a sharp edge. It's the "You mean blah, blah?"/"No, I mean, blah, blah," type of joke. The hard punch line panel is preceded by the all-important *setup line* in the panel before it. Since many comic strip artists and writers aren't that funny, many strips never use the hard punch line. You've seen these strips—they're purposely confusing, camouflaged by a cutting-edge style of art. You read them and feel that you're not hip enough to get the jokes. That's how the strip authors want you to feel. The problem is that these writers aren't funny. If they could write real jokes, they would. If you can consistently come up with hard punch lines, you've got a huge advantage.

The second type of joke makes use of the *soft punch line.* The term "soft" isn't a judgment on the quality of the humor. These jokes can be every bit as funny as hard punch lines, although it's easier for mediocre comic strip writers to think up anemic soft punch lines than anemic hard punch lines. When a hard punch line misses, it misses by a mile. The soft punch line typically derives its humor more from character and quirkiness than from situations. It has a softer edge to it and usually presents itself in the form of a comment, rather than a strong retort. The soft punch line is set up by a preceding *weak* punch line, which is mildly funny or ironic but not funny enough to carry the joke. It needs a "topper." So, the soft punch line in the last panel tops it.

HARD PUNCH LINE

ESTABLISHING PANEL	BEAT (DEVELOPS THE GAG)	SETUP	PUNCH LINE

SOFT PUNCH LINE

ESTABLISHING PANEL	BEAT (DEVELOPS THE GAG)	WEAK PUNCH LINE	SOFT PUNCH LINE (TOPS WEAK PUNCH LINE)

THE HARD PUNCH LINE

Here's an example of the hard punch line in use. Notice that the first panel *establishes* the premise. You find out that the scene takes place in a veterinarian's office, that the old lady is the cat's owner, and what the problem is with her pet. Shove all the necessary information up front, while the reader is patient. You won't have time to introduce it later, and even if you did, it would detract from the flow of the joke. The second panel *develops* the joke. The third panel delivers the *setup,* which begs for the punch line. And, the fourth panel contains the *hard punch line.* (Note that jokes are basically comprised of two different things happening simultaneously on different levels. Here, the old lady's dialogue progresses in one direction, while the veterinarian's goes in another.)

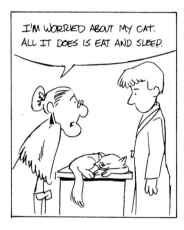 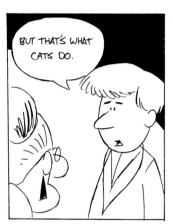 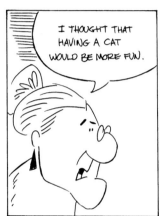 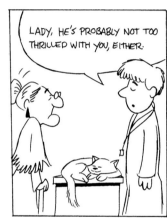

ESTABLISHING PANEL BEAT SETUP LINE HARD PUNCH LINE

THE SOFT PUNCH LINE

Here's an example of the soft punch line. Again, the first panel *establishes* the premise. You see that the scene is in the living room of a married, middle-class couple who are couch potatoes. The second panel is the *weak* punch line. It's funny but not funny enough to sustain the whole joke. It needs a topper, the *soft punch line,* which occurs in the last panel.

ESTABLISHING PANEL WEAK PUNCH LINE SOFT PUNCH LINE

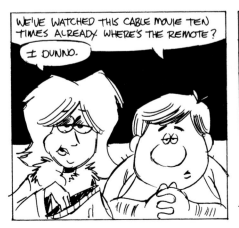 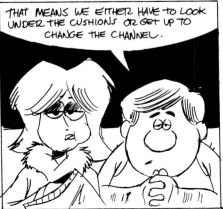 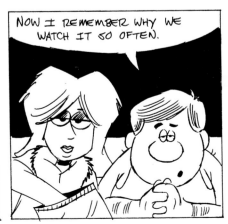

Single-Panel Comic Strips

There are a couple of down sides to single-panel comic strips. First, newspapers pay less for them than for multiple-panel strips. Second, it's harder to develop fully realized characters if you only have one sentence in which to do it. Nonetheless, many popular strips are single panels: *Dennis the Menace, The Family Circus,* and *The Lockhorns,* to name a few.

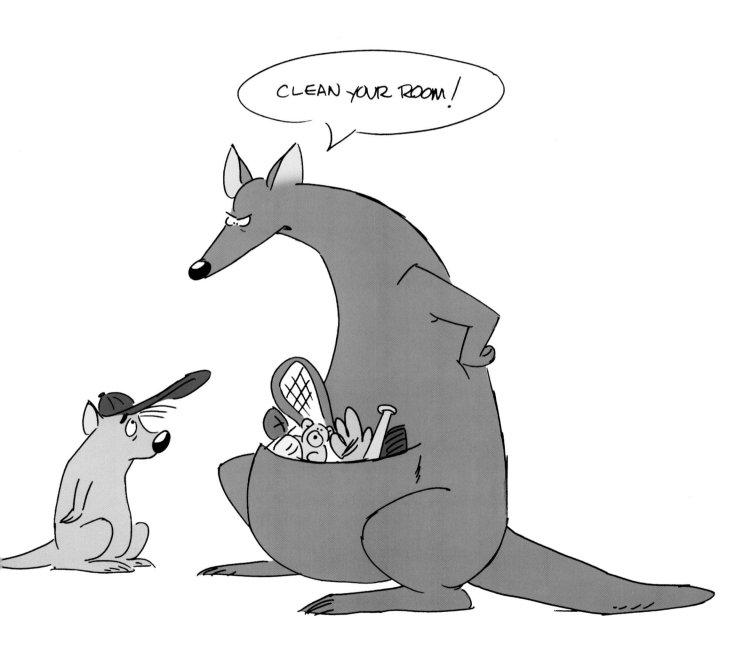

Telling the Joke Visually

You might assume that a single-panel strip is pretty simple, just a punch line. However, take a look at the single-panel strip here. It establishes the premise visually (costumes and location), creates the setup with a visual (the smoke signals), *and* finishes off with a punch line that comments on the visual. Notice how all the elements are carefully laid out so as not to obscure anything. When composing a single-panel joke, take into account that people look at a scene in the same direction that they read—from left to right.

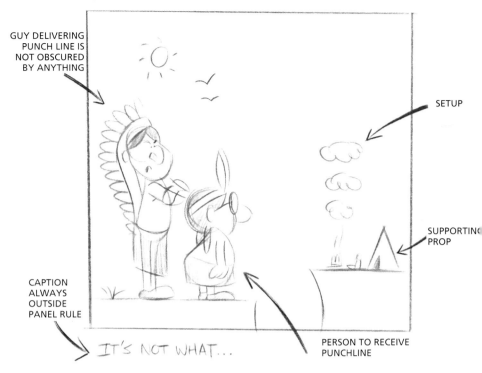

GUY DELIVERING PUNCH LINE IS NOT OBSCURED BY ANYTHING

SETUP

SUPPORTING PROP

CAPTION ALWAYS OUTSIDE PANEL RULE

IT'S NOT WHAT...

PERSON TO RECEIVE PUNCHLINE

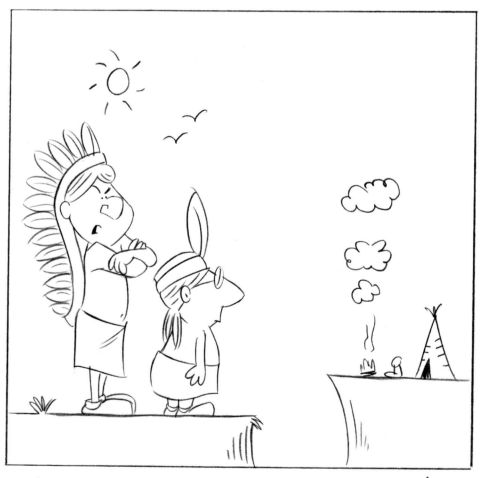

IT'S NOT WHAT HE SAID, IT'S HOW HE SAID IT!

A Joke a Day . . .

Single-panel comic strips and spot gags are excellent forums for gag-a-day jokes—jokes that don't rely on a regular cast of characters or continuing story line but introduce new characters each day. Spot gags are the single-panel cartoons that you see in magazines; they appear without borders, as in the bottom image here.

Artists who become bored easily might not want to create a multiple-panel strip that requires them to draw the same characters week after week, year after year, eon after eon, until the sun turns into a red giant and incinerates the earth and all life as we know it. The single-panel format is perfect for them.

Single-panel strips are also a good choice for those with stranger sensibilities. As this joke with the two snakes illustrates, weirdness often plays better in a single panel.

Note that you can use either a ruler-drawn or a hand-drawn border for single-panel strips. Both are acceptable

TAKE SMALLER BITES!

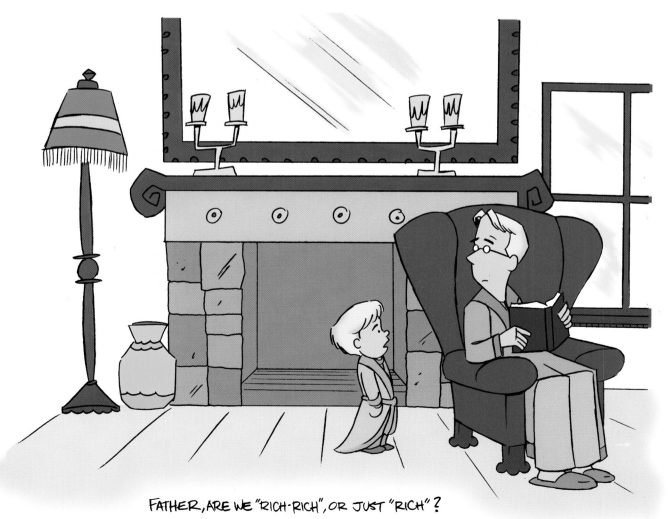

FATHER, ARE WE "RICH-RICH", OR JUST "RICH"?

Choosing the Best Angle

Before committing to an angle, cartoonists will make a series of sketches, known as thumbnails, of a scene. These small, rough drawings of the comic strip panels are used to find the most effective way to illustrate a scenario. It's part trial and error, part intuition, and part common sense. One reason for making these thumbnails so rough is so that you won't hesitate to toss them out if they're not right. Here are a few of the thumbnails for the strip on page 84, which I tossed out before settling on the final angle.

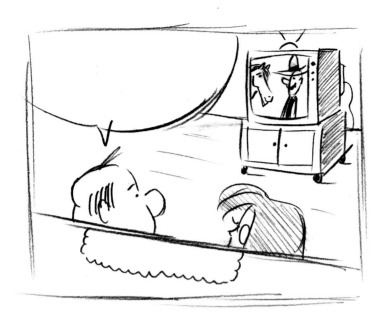

There's too much emphasis on the television; you lose the characters.

The profile angle is too cold, leaving readers uninvolved.

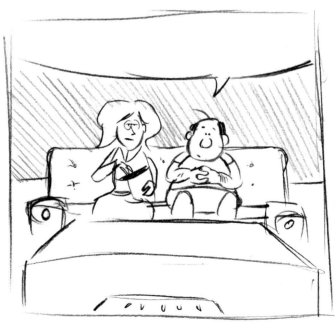

It's a good idea, but the people are too far away.

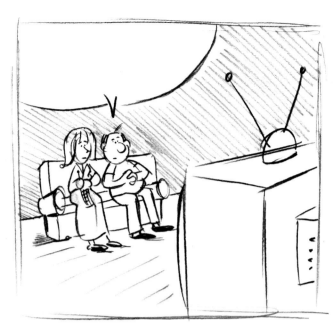

The angle is
too severe.

This is a good angle,
but I've completely
lost the television.

This shows too
much of the room;
it loses focus.

Timing and Rhythm

A steady, even rhythm isn't funny. An accountant isn't funny either. And, an accountant humming a steady rhythm really isn't funny. That aside, you can turn a steady rhythm to your advantage if you abruptly *break* the rhythm at the end of your strip. In this way, you lure your readers into expecting more of the same and then surprise them. Note, in the example here, how the rhythm is changed by the sudden switch to a different location in the last panel. By switching locations, you not only break the rhythm but also indicate a time change (which provides an additional rhythm break).

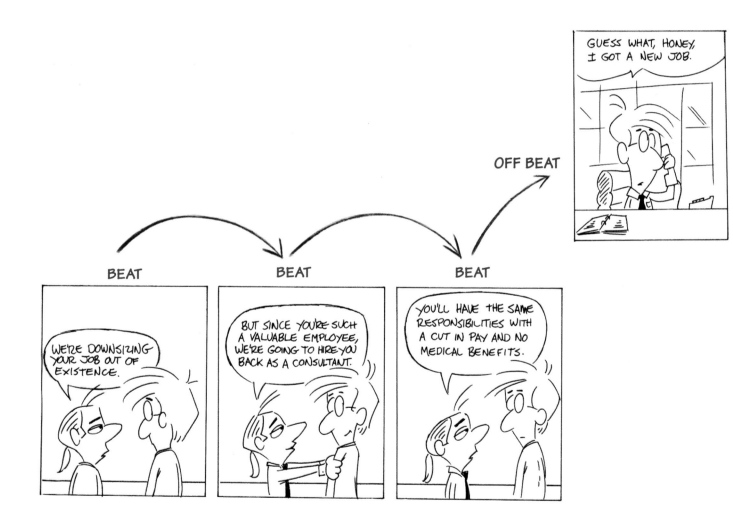

The "Reveal"

The *reveal* is one of the oldest devices in comic strips, but it still remains highly effective. All you need to do is figure out a way to visually hide the punch line from the reader until the last panel of the strip. Then, you go back and carefully set up the joke *without* revealing it visually until the end. Sometimes, the thing to be revealed is kept completely off panel until the final punch line. The nice thing about reveals is that they're visual; since comic strips are a visual medium, reveals capitalize on this aspect. Note that reveals always use hard punch lines, which require carefully crafted setup lines (or visual setups) preceding them.

ESTABLISH THE PREMISE

SETUP LINE

HARD PUNCH LINE (VISUAL)

The Silent Punch Line

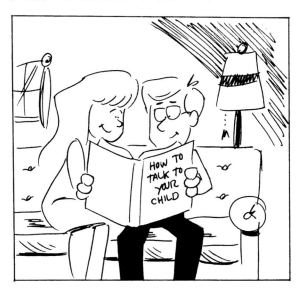

Sometimes a silent punch line is the funniest. If you can say it with pictures, don't say it again by adding redundant dialogue. Note the economy of words in this example. In addition, note that the strip ends where it began, with the parents reading the book on the couch. It doesn't end in a close-up shot, or with the parents seated *similarly* to the way they sat in the first panel, or reading the book in another room. It ends *exactly* the way it began. That's what makes this punch line work.

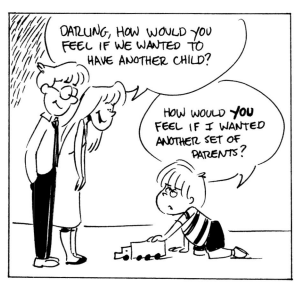

ESTABLISH
THE PREMISE

WEAK PUNCH LINE

SILENT SOFT
PUNCH LINE
(VISUAL)

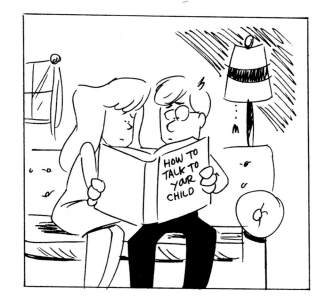

Pantomime

Pantomime can be very funny. We're not talking about mimes. Like everyone else, I believe in capital punishment for mimes. My cousin was a mime, which is one of the reasons we don't speak anymore. Anyway, there used to be a comic strip character named Henry who never spoke. But that's only one interpretation of the use of pantomime.

In the broader sense, pantomime can be used in any strip with talking characters. It's best used when you have characters (who *can* speak) in situations for which action tells the story better than words; therefore, the words are left out. Pantomime is *fun* to look at, and it's *easy*. You don't have to read anything. You know the pictures are going to be effusive, because each one has to tell a story. It's almost like a game, figuring out what's going on in each panel.

Every comic strip can benefit from a few occasional pantomime gags. If you want to see the master of pantomime, look in the margins of *Mad Magazine* at the tiny, wordless figures of Sergio Aragones.

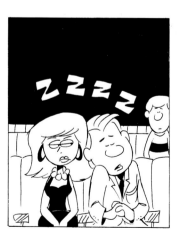

Disjointed Dialogue

Most beginners write predictable dialogue. They think, quite logically, that a character should respond directly to what's being said, which results in such exchanges as, "How are you?" "I am fine." There's only so much of that you can take before your eyes glaze over. If you eavesdrop on conversations, you'll notice that people don't always respond directly to what's being said. They respond *obliquely*. This is very important. In the example below, see if you can sense the energy in the disjointed dialogue. Note that nothing hinges together, yet it's still funny. It's funny *because* nothing hinges together. That's disjointed dialogue. Put it in your cartooning repertoire.

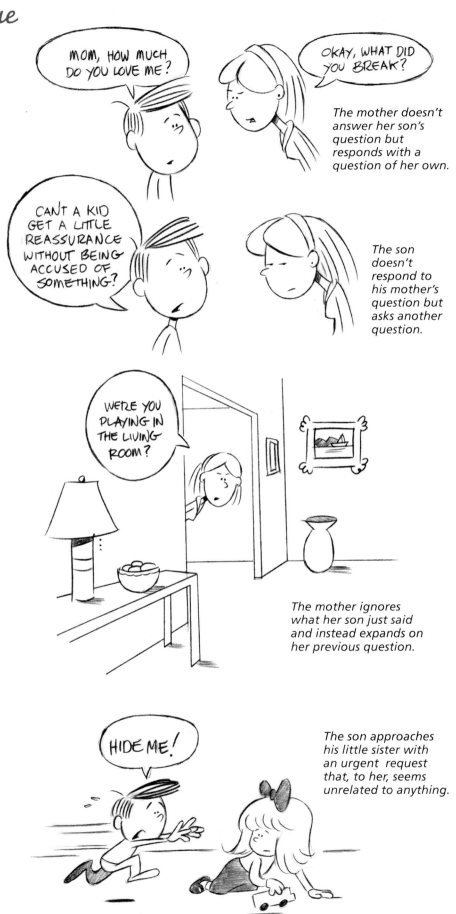

The mother doesn't answer her son's question but responds with a question of her own.

The son doesn't respond to his mother's question but asks another question.

The mother ignores what her son just said and instead expands on her previous question.

The son approaches his little sister with an urgent request that, to her, seems unrelated to anything.

Don't Bury Your Setup Line

Wherever possible, end your sentences with the object of your setup line. Leave it dangling there. This allows it to stand out in the reader's mind. It acts like a springboard, enabling the reader to dive into the punch line, and maximizing its effect. Compare the dialogue balloons below.

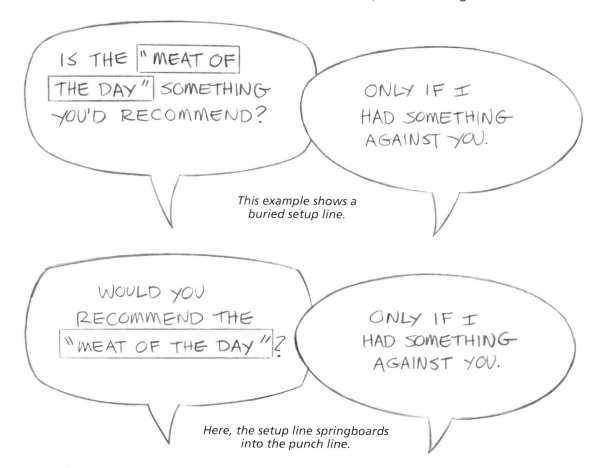

This example shows a buried setup line.

Here, the setup line springboards into the punch line.

STREAMLINE YOUR DIALOGUE

Don't force readers to wade through a lot of unnecessary words. My rule of thumb has always been 18 words or less per dialogue balloon. On rare occasions, I've gone longer, but not often. The strip begins to look imposing. Less than 18 words is even better. Try saying it in 14 words. Then try 12. Keep rewriting down, but stop when the dialogue starts to lose its original meaning or impact.

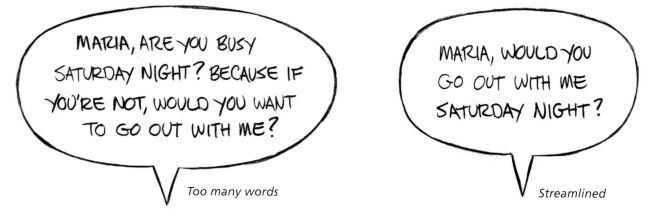

Too many words

Streamlined

Alternative Punch Lines

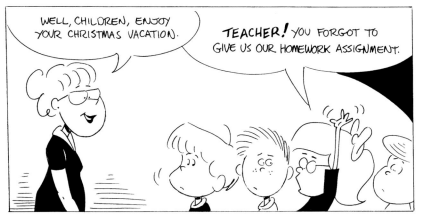

Yes, you have to come up with more than one punch line for each joke. Hey, I didn't ask you to be a cartoonist—it was your idea. Of course, you don't *have* to write alternate punch lines, but if you want all of your gags to sparkle consistently, then this is a very important technique to use. You might be happy with your first punch line, but you won't be sure that it's the *best* punch line until you search for alternatives. Sometimes, you may also have to change your setup line to accommodate a new punch line. In those cases, be sure to devote as much care to crafting the new setup line as you did to the first one. Consider the alternative punch lines for the strip shown here.

The *held* panel is a classic device for creating comic strip humor. This is when you repeat a panel, using an identical panel twice in one strip. By doing this, you hold back the gag, which makes readers anticipate the punch line even more. They're really ready to laugh, and when they get to the punch line, they're primed for it. Once you hold a panel, don't change the angle until you're ready to deliver the punch line, and even then, you can deliver the punch line in the same, held pose, as in the example here. Compare the two versions, and notice how changing the angles actually hurts, rather than enhances, the gag.

HELD PANEL WORKS

CLOSE-UP ANGLE DOESN'T WORK

Economy of Humor

Choosing the right number of panels for a particular strip depends on your material. A traditional four-panel layout may stretch your joke out too thin. On the other hand, if you don't take enough time to set up the joke, it may cost you a laugh.

 Some artists go for fewer panels because it saves time. This is okay, if it works for the material. Also, the more panels you use, the smaller your images will be, and the harder the strip will be to read. Let's see what happens when we place the exact same joke in four, three, and then two panels.

FOUR-PANEL LAYOUT

The four-panel layout is traditional. To tighten it to three panels, you have to decide which is the expendable panel. I'd choose the third one, because the tiny speech balloon there could easily be appropriated by another panel, and it's not a beat that needs to stand by itself.

THREE-PANEL LAYOUT

In order to format this joke in three panels, the entire strip must be redrawn. The second panel now has two people talking instead of one. In addition, the second panel is now the setup panel; due to its importance (and to avoid overcrowding), it's also the widest panel.

TWO-PANEL LAYOUT

Two panels don't give you a lot of time in which to have fun. It's basically get-to-the-point-or-die. In this example, the joke suffers. There's too much going on in the first panel for the reader to digest right away; the son asks his dad for money, the dad gives it, and the son takes it—all simultaneously and way too fast. Trust me, no parents reach into their wallets that quickly. In addition, the last panel isn't as funny with the son appearing in it. It was funnier before, when he had already left the panel, but you can't have the character who delivers the punch line disappear in the last panel if there are only two panels—you'd have just introduced him and then, suddenly, he'd be gone.

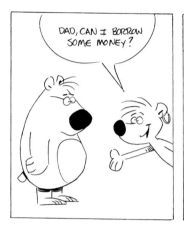
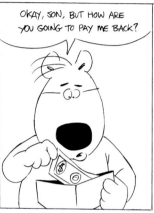
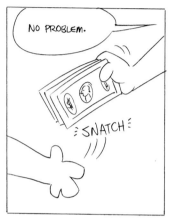
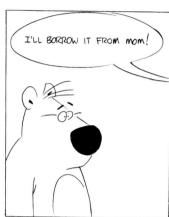

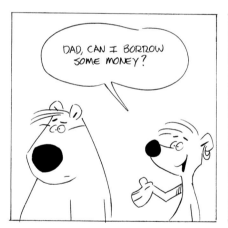
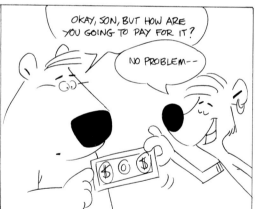
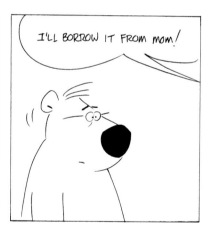

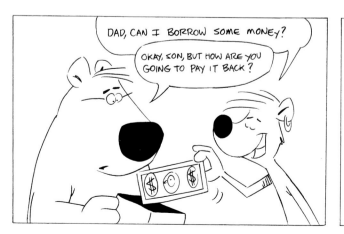
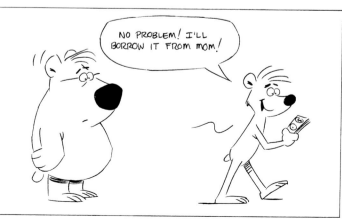

Silent Beats

Which is the funniest of these four images? You're right, it's the third one. What's the capital of North Dakota? Give up? It's Bismarck. But, hey—one out of two isn't bad. That is, unless it was the *second* question that you got right.

Even without dialogue, there's something funny about the third image. Having the right-hand character turn to face the reader helps. Still, even without that turn, this silent "reaction shot" (in which one character reacts to what the other one said) adds a beat to the strip that varies the pacing. Silent beats help break up the predictable rhythm of many jokes. In addition, they allow the setup line to register over *two* panels instead of just one. Notice that the setup line occurs in the second image and continues to sink in over the third, silent image, before the punch line is delivered in the fourth.

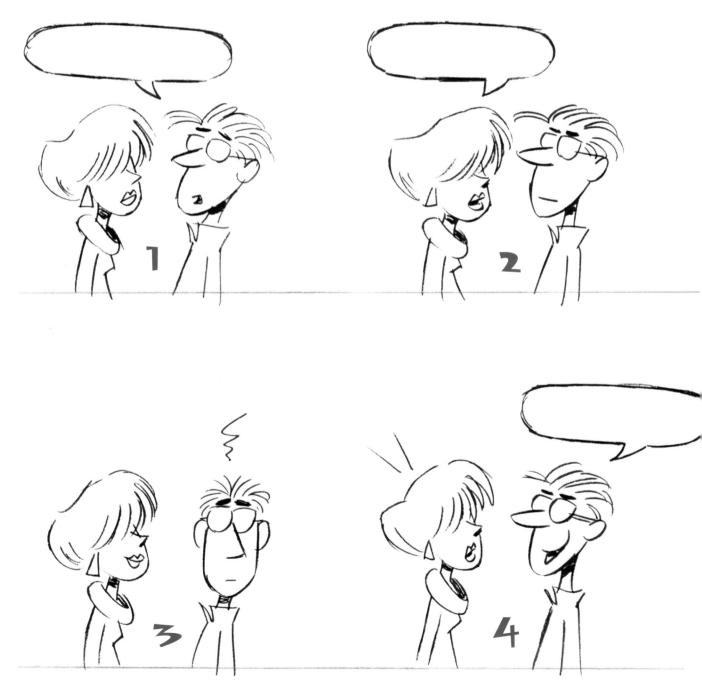

The Delayed Reaction

Delayed reactions are my favorite, with Coney Island–style fries a close second. Very close. Too close. I can't call it. Anyway, the joke below can't end on the second panel. There'd be no place to laugh. You need a place to laugh. The delayed reaction gives readers that place. When the character *gets* what has just happened to him, it's like a big invitation to the reader that says: Hey folks, laugh now.

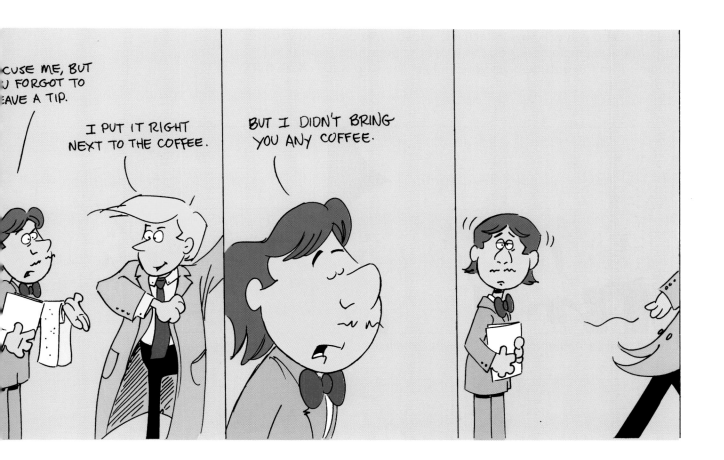

Pacing and Exteriors

You know how, when you jog five miles, you take a break and walk every half a mile or so? That's pacing. You don't do that? Oh. You just run all the way through 'til the end? Okay. But, if you *did* pause every half a mile, this would be a pretty good analogy, don't you think?

Pacing is important in comic strips. Suppose you want to add pacing to your strip, but you have too much dialogue? You can't delete anything, and there's just no way you can cram all the words into three panels to free up one panel for a silent beat. What do you do then? Cut to an exterior scene.

"It can't be that simple!" you cry out incredulously.

"Oh, but it can," I rejoin calmly, reassuringly.

Just cut to an exterior image, and then cut back to the interior scene again in the following panel. You don't have to cut out any dialogue, and you will have effectively added some pacing to your strip. In the example here, you can sense the breathing room that a simple cut to the outside gives you, and yet the strip is still chock full of dialogue.

Cutting from an interior to an exterior helps accommodate a lot of dialogue.

Another popular method for varying the pace is to break up the strip with a long-shot silhouette of your characters. A fairly high horizon line works best in this type of panel.

More about Exteriors and Layout

Note the following tips on good layout and the effective use of exteriors in your comic strips.

This is an unsuccessful layout. Panels two and three should be merged into one large panel. Avoid these types of weird layouts. Note, however, that an exterior works well for a final panel punch line.

Here's another bad layout. In daily comic strips (as opposed to the longer Sunday strips), don't cut to an interior from an exterior, or vice versa, more than once. It looks unconnected, as if it's two separate comic strips in one.

This is a good layout and use of exteriors. When all the dialogue occurs in exterior shots, you don't have to cut inside to change the pacing. If you cut inside to show the characters for only one panel, you'll make readers feel that they've been slighted, not getting to see more of the people all along. So, if you're going to focus on exteriors, stick with them. Only use this type of an exterior layout with well-established comic strips, otherwise readers won't know what they're looking at or who is saying what.

Creating a Sunday Strip

Coming up with a Sunday comic strip can be a daunting task. The strip is in color. It has more panels than a daily. It commands a higher fee than a daily. Plus, more people read the paper on Sunday than on any other day. Monday is the second most popular day, and then readership continues to trail off, with Saturday attracting the fewest readers. This is why you'll see the weakest gags in Saturday comics.

There are two approaches that I've found very useful in creating Sunday strips. The first method (illustrated here) is to take a strong daily strip gag and convert it into a Sunday strip. However, the gag's got to be strong enough to allow you to pad it with extra panels without weakening the humor. It also has to be a gag than builds well to a punch line, since you're going to use more panels to get there. The second method (shown on page 106) is to take advantage of the Sunday strip's longer format to tell a little story with a funny ending.

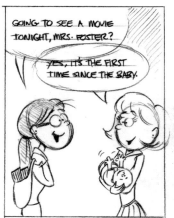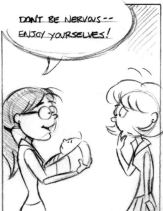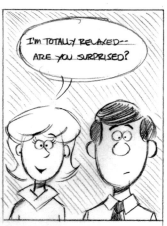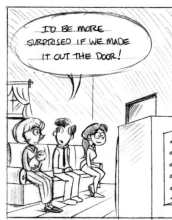

CONVERTING A DAILY INTO A SUNDAY STRIP

Above is a roughed-out daily with all the elements that make a good candidate for a Sunday strip. In the converted Sunday strip opposite, note how the additional build-up time adds to the punch line. It's not simply extra material included just for the sake of adding panels. Note, too, that the first panel in Sunday strips is sometimes reserved for the strip logo. Also, a large panel for the punch line is a luxury you get with a Sunday strip—use it.

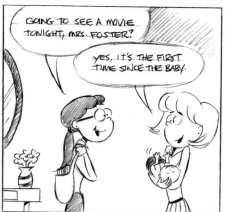

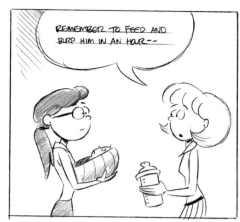

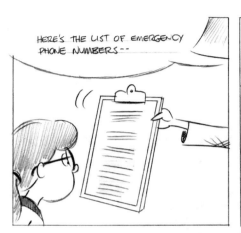

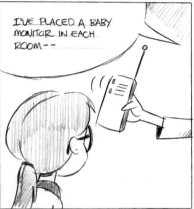

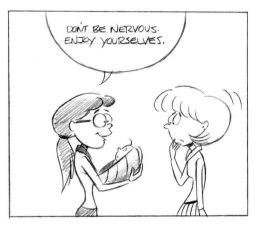

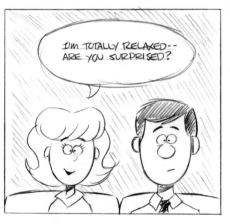

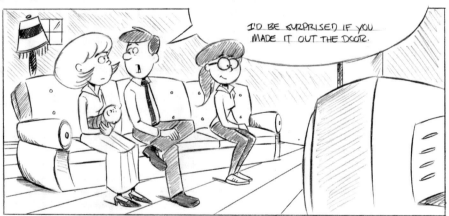

COMIC STRIP DIMENSIONS

Daily comic strips are drawn at 3⅞ x 13 inches and then reduced from this. The interior panels can be any length, as long as they all fit into the overall 3⅞ x 13-inch parameters.

The Sunday strip is three daily strips stacked on top of one another. Some syndicates may have different size requirements, requiring only two rows. Each syndicate will let you know what they ultimately want, but you can submit a Sunday comic strip to any syndicate in either format. Single-panel strips are drawn 7 x 7 inches, although there are some variations. Again, the syndicates will tell you their exact requirements.

Telling a Short Story

This alternate technique for developing a Sunday strip involves telling a little story that has a joke at the end. Let your readers enjoy the ride to the punch line. Widen the boundaries of the comic strip by showing different locations or by introducing more characters. Give readers an intimate look at the characters' world—something that isn't always possible in a four-panel daily. For example, in the Sunday comic shown here, the entire family is introduced altogether in one strip story; this probably wouldn't occur in a daily. Another thing to note is that unlike a daily, which is just a gag, a Sunday strip should have a beginning, a middle, and an end.

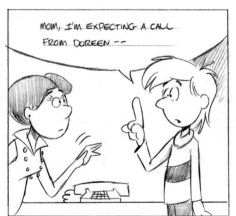

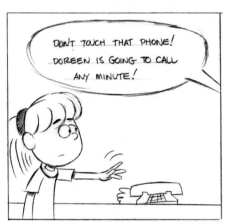

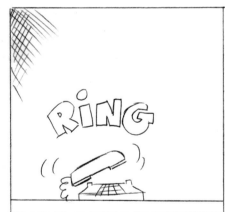

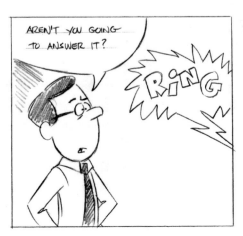

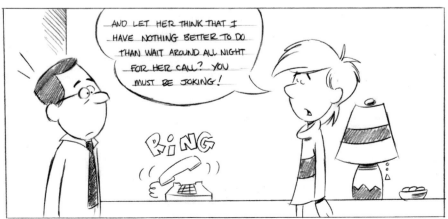

Some words are funnier than others. Always search for the funnier word to express what you want your characters to say. Listen to stand-up comedians; they're masters at selecting funny-sounding words with which to pepper their routines. The difference between regular and funny words is that funny words are more specific, funny or zippy sounding, slightly gross, and/or "low rent."

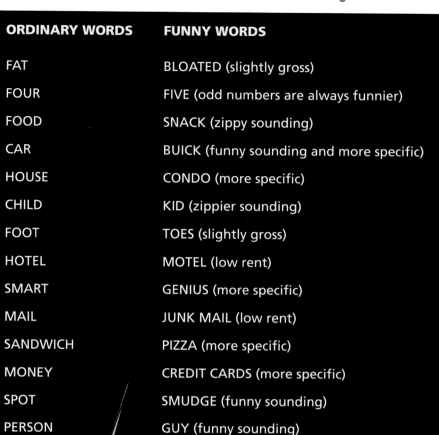

ORDINARY WORDS	FUNNY WORDS
FAT	BLOATED (slightly gross)
FOUR	FIVE (odd numbers are always funnier)
FOOD	SNACK (zippy sounding)
CAR	BUICK (funny sounding and more specific)
HOUSE	CONDO (more specific)
CHILD	KID (zippier sounding)
FOOT	TOES (slightly gross)
HOTEL	MOTEL (low rent)
SMART	GENIUS (more specific)
MAIL	JUNK MAIL (low rent)
SANDWICH	PIZZA (more specific)
MONEY	CREDIT CARDS (more specific)
SPOT	SMUDGE (funny sounding)
PERSON	GUY (funny sounding)

HUMOROUS LAYOUT AND DESIGN

I t's a good thing you want to be funny, because it's a heck of a lot easier to stage humor than drama. A funny scene is flat, symmetrical, and obvious. A dramatic scene incorporates angles, foreground and background dynamics, and asymmetry. This chapter covers everything you need to know about designing humorous comic strip panels. Note the different approaches to staging comedy and drama on the facing page.

DRAMATIC
Notice the heavy angles and foreground/background dynamics in this scene.

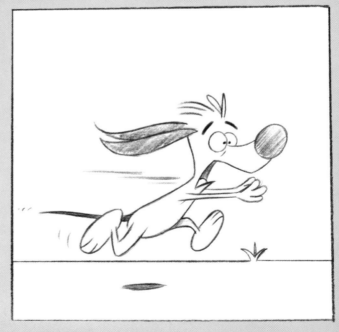

FUNNY
This illustrates the same action as in the previous panel—running—yet the scene is flat and symmetrical.

Dramatic scenes have a very different feel and look than comedic ones. Compare the following panels, and note the contrasting angles and staging.

DRAMATIC
Note the strong foreground and background dynamics in this panel.

FUNNY
Although there are the same number of characters here as in the preceding panel, the scene is symmetrical, flat, and obvious.

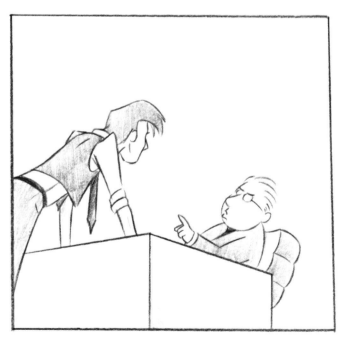

DRAMATIC
This is a heavy angle.

FUNNY
The humorous version is flat.

The Closer You Get, The More Detail You See

This concept sounds so obvious but is often overlooked. The farther the object is from the reader, the *less* detail it should have. The reverse is also true. The closer the object is to the reader, the *more* detail it should have. This is in keeping with the basic principles of perspective.

From a distance, the dog is simplified with only dots for eyes.

As the scene becomes more of a close-up, the dog's eyes, eyebrows, fur, and body curves all become pronounced.

In the actual close-up panel, maximum detail is used. Be careful not to overdo it; this is cartooning, not photorealism.

When to Go Close and When to Go Wide

Filmmakers aren't the only ones who think in terms of close-ups and long shots; comic strip artists must also take these "camera angles" into consideration. Think of the readers' eyes as the camera, for in fact, they'll be looking at the strip from the same position as a movie camera would be shooting the scene.

There are no hard and fast rules about when to cut in closer and when to pull back to widen out. However, the usual, most palatable technique for cutting in and out of a scene is as follows:

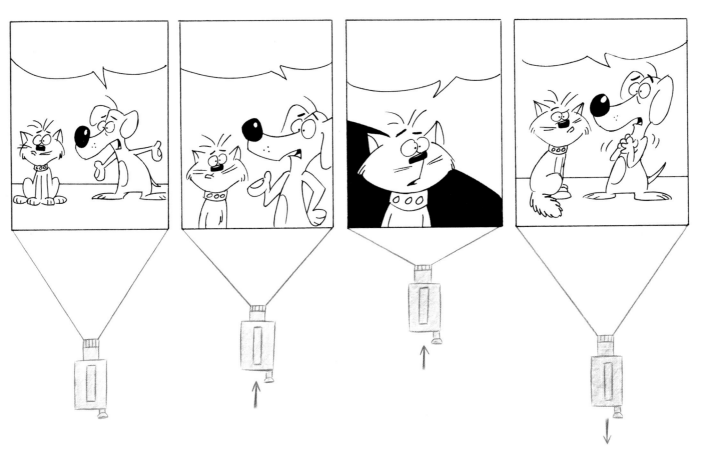

Start wide. This helps to establish the scene. The reader sees who and where your characters are and to whom they're talking.

Move in for a medium shot. The scene has already been set, and you can focus more on your characters. But, tiptoe in—don't make any huge leaps that are jarring to the eye.

Go close. Here's the setup line—the most important panel of the gag. Move in close to give it weight.

Go wide at the end to re-establish the scene for the punch line. Readers will also want to see the reaction of the other character. Going wide visually punctuates the end of the gag.

Cutting between Panels

There are three ways in which cartoonists typically move, or cut, from panel to panel, and all are good. The first requires the most drawing but also allows you to see more of the characters. The second is the clearest. And, the third is the most dynamic.

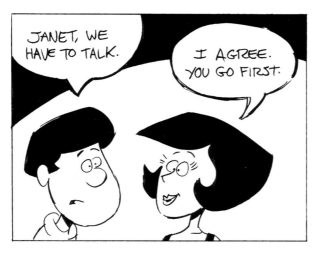

By varying the middle panel, you add interest to an otherwise static scene.

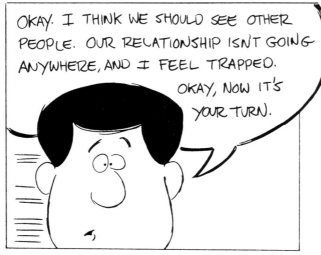

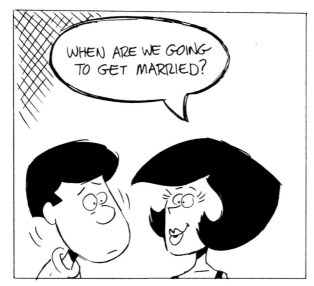

TRADITIONAL METHOD

In this example, all the shots are wide. Each panel shows everything. You don't emphasize or de-emphasize any particular panel. With this approach, you need to exaggerate the gestures of the characters, otherwise you'll have two guys standing there doing a whole lot of nothing. Like two uncles at a wedding.

CUTTING IN AND OUT

The second approach keeps the establishing panel from the first example. It then cuts in for a medium shot and moves to a close-up, before pulling back for a wider shot to re-establish the scene at the punch line.

CHANGING ANGLES

The third method uses *reverse angles*. After the establishing panel, the strip cuts to a medium-range shot over the shoulder of one character. In the following panel, the angle is reversed (hence the name) and moves in even closer for a tight, medium-range shot over the other character's shoulder. Then, the scene is re-established at the punch line. This approach utilizes these "camera" angles so dynamically that the characters' gestures should be very subtle to avoid confusing the reader.

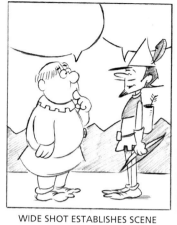

WIDE SHOT ESTABLISHES SCENE

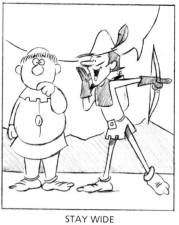

STAY WIDE

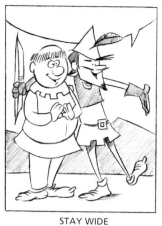

STAY WIDE

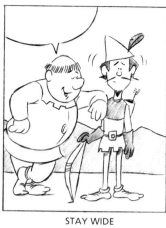

STAY WIDE

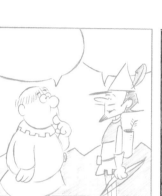

SAME

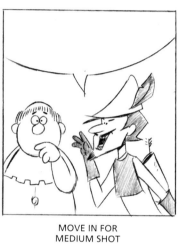

MOVE IN FOR
MEDIUM SHOT

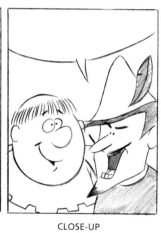

CLOSE-UP

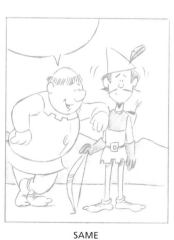

SAME

SAME

MEDIUM SHOT
(FAVORS REACTION)

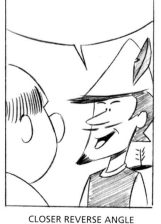

CLOSER REVERSE ANGLE
(FAVORS SETUP LINE)

SAME

Crossing the Line

Take a deep breath. It gets easier after this. If you start cutting in and out when you're staging your strip, sooner or later you'll make the really stupid mistake that I'm going to explain here—unless you learn this technique that is. If you don't learn it, you'll regret it. Maybe not today, maybe not tomorrow, but soon, and for the rest of your life. I've been waiting years to use that line.

In every scene, there is a line that divides the circular area around your character into two 180-degree arcs, parts A and B. To decide where to divide the scene, you draw this line halfway through the circle, parallel to the "camera." Remember that the camera represents the reader's eye— what the reader is actually seeing. After you establish the frontal 180-degree arc (part A), the camera, or eye, must never cross the dividing line to shoot in part B.

Whenever you move the camera, even just slightly, you get a whole new 180-degree area in which to work. You can move around the character completely, as long as you do it gradually over a series of panels and don't cross the line abruptly on any one cut.

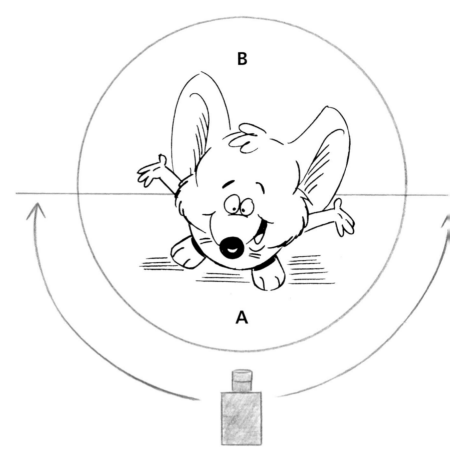

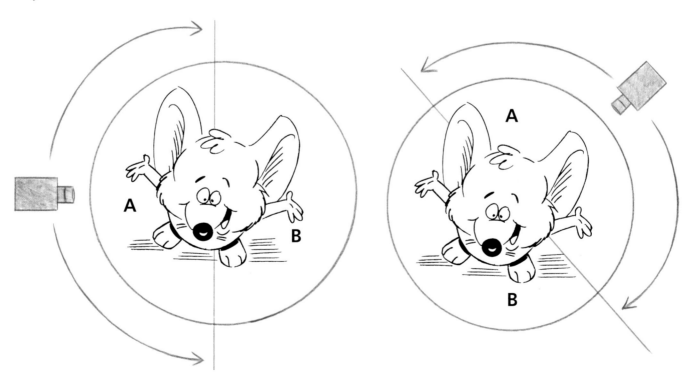

What happens if you do cross the line? You'll confuse the heck out of your readers. They won't know where the characters are positioned in relation to one another. To better understand this, let's look at this example of a scene with a horse talking to a chicken. The scene starts with the camera (the reader's eye) in position 1. We draw a line parallel to the camera creating our 180-degree working area. When we move the camera to position 2, it's still on the correct side of the line, but when we move it into position 3—boo, hiss. We've just crossed the line and lost our readers.

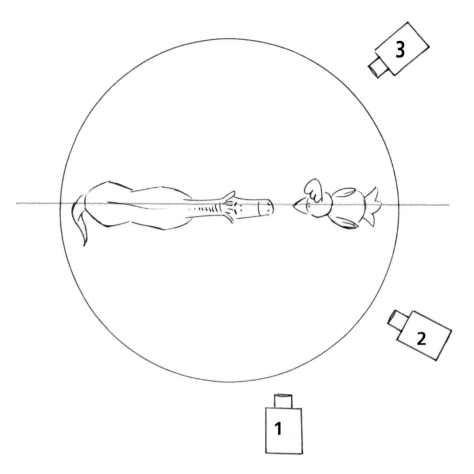

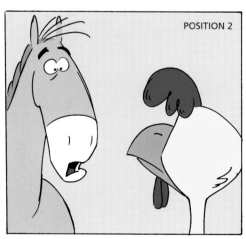

RIGHT
This shows the "camera" in position 1 in the first panel, and position 2 in the second panel. It looks like a natural cut. The camera has simply been pushed in a little closer over the chicken's near shoulder.

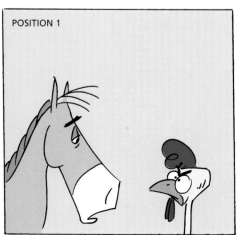

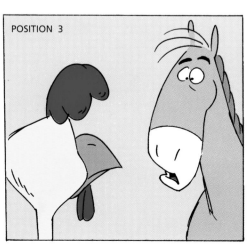

WRONG
This example starts at position 1 but has the camera cross the dividing line, moving around to the other side of the chicken to get a closer shot of the horse from over the chicken's far shoulder. It's a weird view. It's disjointed, and it's going to look weird again when the scene cuts back to the correct side of the dividing line.

Cast Shadows

When an object blocks light, it casts a shadow. The light can come from any source—natural sunlight or indoor lighting. By adding shadows to your drawings, you create a sense of depth and your illustrations don't look so flat. Generally, the light source is assumed to come from overhead, especially for humor. Under-lighting is reserved for drama, suspense, and horror.

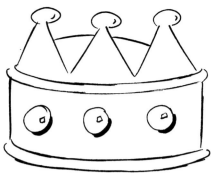

Note the cast shadows under the three round jewels in this crown.

The overhang of this tabletop casts a shadow onto the chest of drawers underneath.

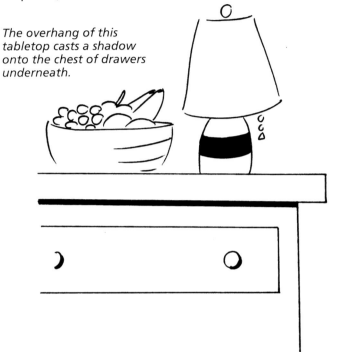

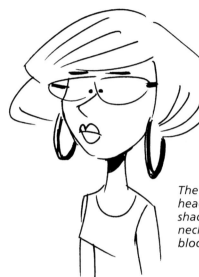

The chin and head often cast a shadow on the neck as they block the light.

During a running or walking motion, the front leg casts a shadow on the rear leg, causing it to appear to recede.

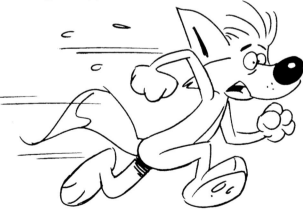

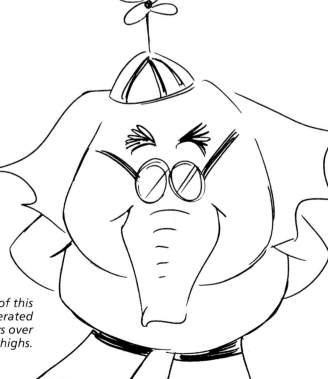

The girth of this character is exaggerated by adding shadows over the tops of the thighs.

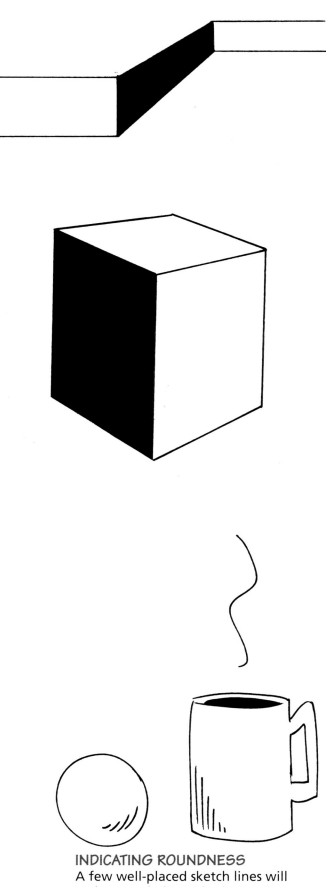

CHANGING PLANES
When you make a change in plane (a change of angle), you also create a change in value (brightness). Take a look at the three-angled edge at left. At the point at which it changes planes, it exhibits a shadow. Looks pretty crisp this way, doesn't it? For the box with *three* planes, *one* shadow is all that's needed to break up the monotony of the flat sides and give the shape a three-dimensional appearance.

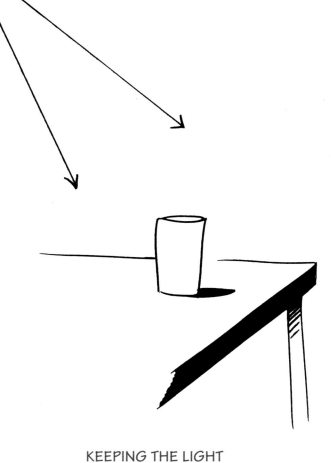

INDICATING ROUNDNESS
A few well-placed sketch lines will make round objects look rounder, as in this ball and mug.

KEEPING THE LIGHT SOURCE CONSISTENT
Light from one source results in shadows that are all cast in the same direction. So, in this example, the shadow should appear on the same edge of the tabletop *and* side of the glass.

Using Blocks of Black

Six out of every seven comic strips appear in black and white; these are the dailies—only the Sunday strip is in color. Most magazine spot gags and all newspaper editorial cartoons are also in black and white. Your comic strip will be competing with many others on a page for the reader's attention, so anything you can do to increase its visibility will be an asset. To make your black-and-white cartoon stand out, add blocks of black.

NIGHTTIME SILHOUETTE VS. DAYTIME SILHOUETTE
You might think the house with the light windows is the daytime silhouette, but a dark house with windows aglow reads as a night scene. The house that's totally in shadow reads as the daytime silhouette.

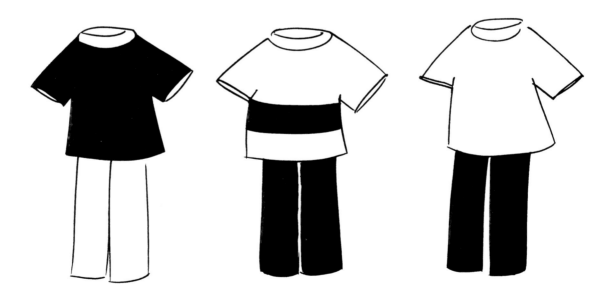

ALTERNATING BLACK WITH WHITE
Don't allow your strip to become so overrun with black that it becomes grim, and be careful not to place too many blocks of black side by side—you'll start to loose the interior form of an object. A better idea is to alternate blocks of black with blocks of white. Notice how clearly these clothing outfits read.

Some artists use a *non-photo* blue pencil to make an initial sketch. The advantage to this pencil is that it doesn't reproduce when photocopied. You can ink over it and only the ink lines will show up in a photocopy. However, it feels waxy, as if you're drawing with a candlestick, and it doesn't erase.

Other artists, yours truly among them, prefer sketching with a regular pencil, and then tracing the final copy on a new piece of paper in ink. Some sketch lightly in pencil, draw directly over it with ink, and then erase the pencil so that only the ink lines remain.

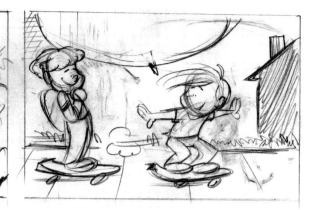

SKETCH
This is the initial pencil sketch.

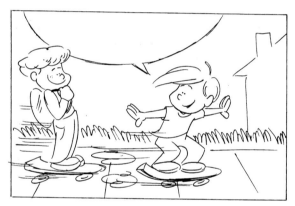

FINAL INK—NO BLACK
Even though the final ink is a good, spirited cartoon, it looks empty without blocks of black and, therefore, lacks impact. It would get lost on the comics page, competing against other strips.

FINAL INK—WITH BLACK
Now the strip really pops. Note that there's no area to blacken in the second panel, so I create an area by drawing an arching shadow behind the boy. This causes his head to come forward and the background to recede. In addition, I alternate blocks of black between both kids' clothing, and hair. Note the daytime silhouette of the house, as well.

Designing a Panel—Do's and Don'ts

DO leave more room in front of a character's head than in back of it. There should also be more space in the direction the character is facing.

DO place characters in the middle of the panel when they're facing the reader.

DO lay out the action in a panel in the direction that people read—from left to right. Here, the duck on the left is causing the action, and the snake on the right is reacting to it—left to right.

DO stagger speech balloons when you have more than one in a panel.

DON'T use panel lines as walls, floors, or ceilings.

DON'T cut off characters' heads with a panel line.

DON'T cut your characters off at the feet.

DON'T make your characters too big; they'll look like giants.

Designing Speech Balloons

There are many options when choosing a speech balloon style. You don't have to be married to one approach. It's best to mix 'em up.

Put the speech balloon near the top of the panel, slightly to the left or the right. This is the standard; you can't go wrong with this approach.

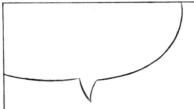

Use the top and side of the panel to cut off the speech balloon. With this approach, you'll increase the space within the balloon and, therefore, the amount of words you can put inside. Remember this one when you've got a lot of dialogue.

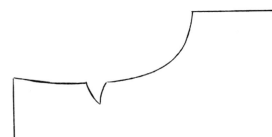

This is the same as the example at top right, with the top and side panel lines eliminated. It's a pleasing look.

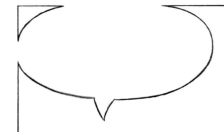

Bump the balloon into the panel, and eliminate the lines where they touch. This is a nifty look.

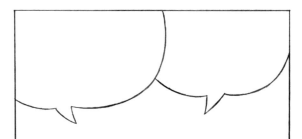

Two large balloons in a panel feel more comfortable if they overlap each other . . .

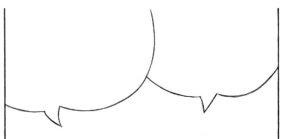

. . . but don't leave off the top panel lines with this style. It looks weird. And, it makes me mad.

Never let the balloons touch each other without overlapping. This also gets me steamed.

Increasing the Size of Speech Balloons

Let's say you've got some dialogue that you just can't edit down without destroying the gag. You'll need a whopper of a speech balloon, but you don't want it to overwhelm the panel or drawing. What should you do? Here are the three approaches I recommend.

Increase the size of the balloons and let the characters overlap them.

Lower the characters in the panel so that the balloons have, and take up, more room.

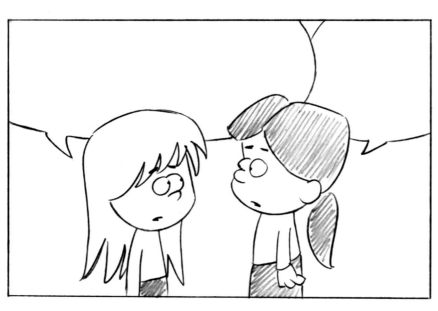

Lengthen the size of the panel. This allows the balloons to accommodate more words without necessitating pushing the balloons halfway down the page and squeezing out the characters.

Using Balloon Connectors

Adding connectors between balloons is a good way to show a back-and-forth conversation within a single panel. It has a nice symmetrical look. However, if the panel starts to get cluttered with words, it doesn't matter how well you've laid everything out—it's better to continue on another panel. Note the sequence in which connected balloons are *always* read: top line, left to right; next line, left to right, and so on.

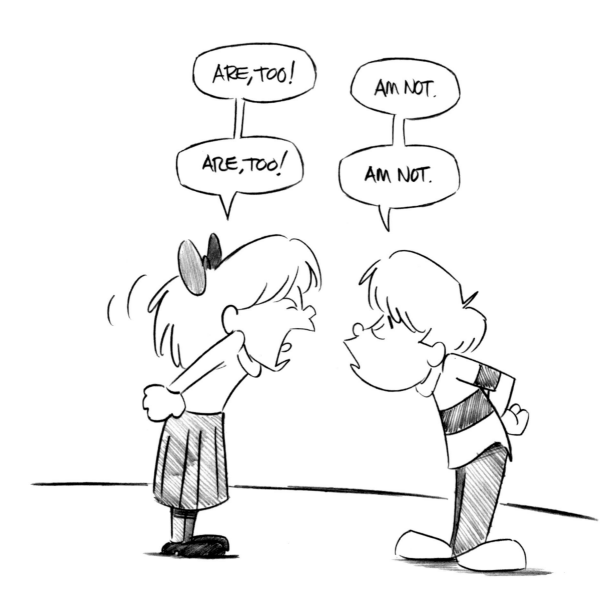

Layered Balloons

It's often more common to use layered speech balloons, rather than connectors, to convey back-and-forth conversations. The advantage to this is that the order in which the words are being spoken is clearer than it is with connectors. Note: Be sure to stagger the balloons; you don't want them to appear as one lump.

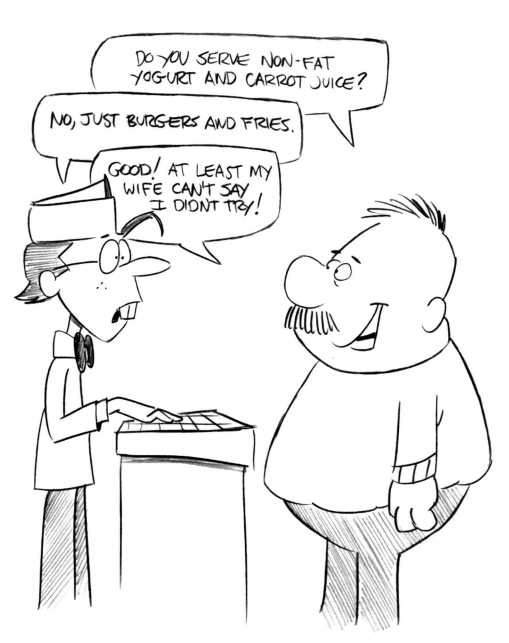

Double Balloons

When one character has two separate ideas, you can illustrate both in a number of different ways. Compare these four samples:

I AGREE!

...BUT ON SECOND THOUGHT...

Use two separate balloons for the two ideas.

Partially meld the two speech balloons with the same effect.

I AGREE!

...BUT ON SECOND THOUGHT...

Note the placement. Don't position a large balloon between two characters who are having a conversation. It looks like a blockade.

I AGREE!

...BUT ON SECOND THOUGHT...

I AGREE!

...BUT ON SECOND THOUGHT...

Relocate the balloon instead and reduce the distance between the characters.

Rules about Speech Balloons for Animals

Surprised that there are rules for this? Maybe you're one of those people who doesn't think the rules apply to him—who tears the tags off mattresses, who turns up the car radio when driving through hospital zones. I've got your number, fella.

Anyway, there *are* rules when it comes to cartoon animals talking to one another. You can, of course, break these rules, but convention goes as follows:

ALL-ANIMAL COMIC STRIPS
For a strip in which all the characters are animals, they all "talk" just like human characters, with regular speech balloons.

STRIPS WITH ANIMALS AND PEOPLE

For comic strips in which people have pets, the animals "think" to the people in thought balloons (scallop-shaped balloons with bubbles that trail off toward the character who's having the thought), while the people speak to the animals in regular speech balloons. The people cannot hear what the animals are saying in the thought balloons, but the animals can hear what the people say in the regular speech balloons. Animals can also address other animals, as well as readers, in thought balloons, and they can "hear" other animals' thought balloons. This makes the animals seem smarter than the people.

People can't hear what animals are thinking in their thought balloons.

Animals can hear one another's thought balloons.

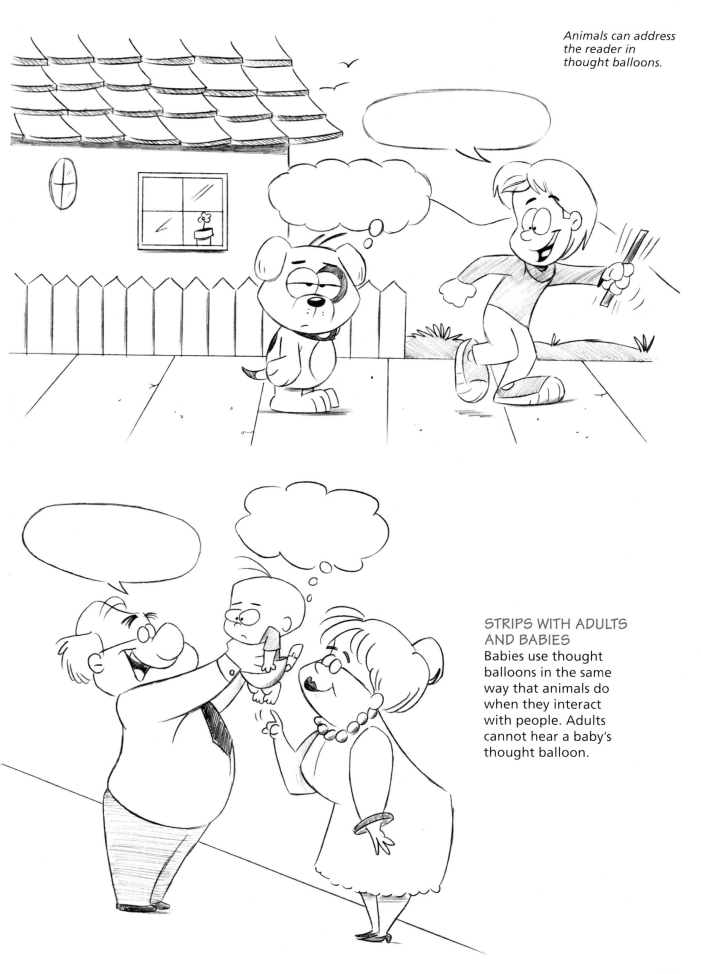

Animals can address the reader in thought balloons.

STRIPS WITH ADULTS AND BABIES
Babies use thought balloons in the same way that animals do when they interact with people. Adults cannot hear a baby's thought balloon.

Sound Effect Panels

A great tool to use for pacing is a panel that's entirely taken up by a sound effect. Sound effects such as "THUD," "BLAM," and "KA-BOOM" are always written all in capital letters for emphasis. As in every aspect of cartooning, there are effective and not-so-effective techniques. Consider the following:

You actually like this approach? Smack some sense into yourself! This doesn't have nearly enough impact. The panel is mainly empty space.

Better. Note the alternating tilt of the letters. This is a frequent approach and is adequate, but it's like wearing one brown sock and one black sock to a party. It'll get you there, but not in style.

This is the mother of all sound effect panels. There ain't no daylight in this panel; the THUD takes up all the space. Now that you see how effective this approach is, you may want to join me in mocking and scoffing at anyone who still prefers the first method.

COMBINING SOUND EFFECTS AND PICTURES

When you combine pictures with sound effects, remember two things: Stylize the letters, and don't be timid about making the letters BIG.

SCHOOL LIBRARY

How important are background drawings? Very. But, they shouldn't *look* very important. In drama, the background is used to add atmosphere, tone, and tension to a scene. For example, a broken watchtower, an abandoned building, or a broken window would all enhance a dramatic scene.

In comedy, however, if your readers are focusing on the background, you've lost them. Good-bye. Go home. Take that job as an insurance claims adjuster.

Just pack up and get out of town. (The exception to this is fantasy, including science fiction, in which the backgrounds serve as reminders for readers to suspend disbelief.) For comic strips, humorous backgrounds are key to establishing a scene. They tell readers where they are so that you don't have to waste a lot of dialogue explaining this. Funny backgrounds should be flat, familiar, simple, symmetrical, and cheerful.

BIKE-RIDING TRAIL

Choosing the Right Locations

Drawing the backgrounds isn't as difficult as figuring out *which* backgrounds to draw. Choosing the right background is just as important as casting a new character. You're introducing readers to your world; if they like it, they're apt to return.

The first step is choosing and establishing the locations that will recur most frequently in your strip. In a kid's strip, for example, you've got to figure out where the kid will appear the most. Basically, it'll be at home and at school. Then you should decide *where* at home and *where* at school your character will be primarily. The locations should be places to and from which other characters can easily go, because you'll need the other characters to ignite the humor. Show your character in kid places doing kid things, such as schoolwork, eating, sleeping, playing, and talking.

Expand your character's world. If your main character's primary location is school, come up with specific sites within the school besides just the classroom. The classroom may be the home base, but there are also always school hallways, bike racks, and gym class—and gym uniforms are always funny. Gym teachers are also funny—when they're not being psychotic.

You should focus on repeating three or four main locations, and sprinkle the other places in occasionally. Familiarity is more important than variety. A comic strip is like a comfortable old slipper. If you rarely repeat the same location, readers will never get comfortable with your strip. Note also that your locations must be conducive to talking and/or action. In a kid strip, the classroom and the bedroom are good for both.

SCHOOL CAFETERIA

SCHOOL BUS

Popular Panel Configurations for Daily Strips

As long as the measurements of your comic strip total 3⅞ x 13 inches, you can draw the individual panels in any dimensions you like.

This is the traditional four-panel setup.

This is the traditional three-panel setup.

A borderless middle panel offers a nice variation.

Here, the first panel holds a big visual, leading up to the succinct punch line in the smaller second panel.

For a change of pace in the middle try two small panels surrounded by large panels.

Five or more panels is rare, but some dialogue requires it. In these cases, forget about showing any gestures or actions within the panels—there just isn't any room.

Bordered panels alternating with borderless panels create a nice look.

The long strip is almost always a visual gag.

When a sequence doesn't change locations and there aren't any time cuts, it's more pleasing to eliminate the dividing panels altogether. Readers will still follow the sequence, and the strip will exude a feeling of freedom and energy that panels tend to curtail. In addition, this open quality will stand out against the other daily strips on the comics page.

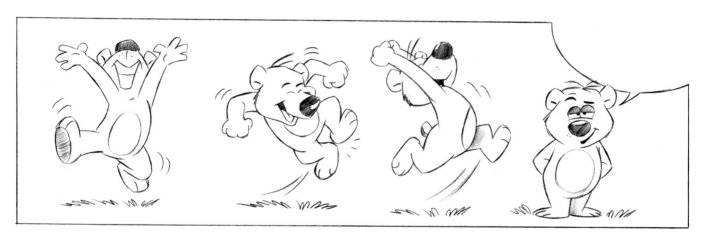

EVERYTHING YOU NEED TO KNOW TO BE A PROFESSIONAL CARTOONIST

So, you want to make the jump from "aspiring" to "professional." You want to be published. To do this, you can make submission after submission, hoping for the best. Or, you can follow a few simple suggestions that will immediately distinguish you from novices. A professional editor can spot an amateur immediately. It's the person who submits the wrong amount of strips, in the wrong size, in the wrong format, and always in a fancy binder with a big, fat copyright warning on the cover.

Of course, you don't want your work to be published just one time. You want it to continue to be published. To do this, you'll need to know a few tricks, such as dealing with writer's block, meeting deadlines, and working with a partner. Can you learn these things over time by yourself? Absolutely. However, the mistakes you could make along the way could cost you. It could cost you your strip, in fact. Not to worry. This section of the book is designed to put you in serious contention in editors' minds and to give you staying power.

Newspaper Demographics

You might think the biggest audience for comics is children. Wrong. It's adults. More adults read comics than kids, so there's got to be something in the strips for them. Keep that in mind when you create your comic. Sure, *Peanuts* is popular with children, but it's the adults who get all that sly, sophisticated humor. Remember Lucy with her storefront psychiatric office? How many eight-year-olds do you think got that? The children got the individual punch lines, but it was the adults who were amused by the lemonade-stand psychiatrist "office." Even *Garfield*, which is kid-oriented, displays the mean-spiritedness of adult comedy, with a goodly amount of droll humor sprinkled in. Since you can't appeal to every reader with the same strip, newspaper syndicates try to buy strips that appeal to specific reader markets. These markets include:

Children
Women
Young professionals
The middle class
Parents
The politically aware
Senior citizens
 (This is not a popular group. Most, but not all, strips have failed trying to rely on a significant senior readership.)
Ethnic groups
Teenagers and college students

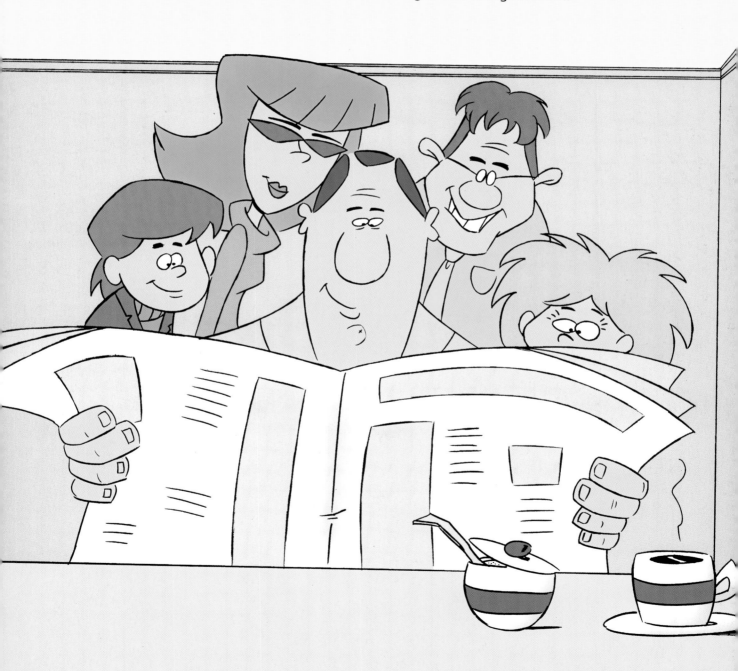

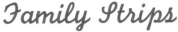

Family Strips

Due to the broad cross section of markets to which it appeals, the family comic strip has consistently been the most popular genre. In one strip you've got men, women, children and/or teenagers, and even a pet. Everyone has a family, so the strip is bound to relate to somebody.

A family strip cuts a wider path across the marketplace. However, it's also a well-traveled path; to be successful, you've got to bring something really fresh to the picture. The challenge is deciding what type of family to create. For example: Is it neurotic? How and to what degree? On whom does the strip focus? The son, the daughter, the mother, or the father? You've got to ask yourself these really tough questions.

First off, whenever you send your strip for submission to newspaper syndicates, include a self-addressed, stamped envelope with it for the return of your materials. Send your submission by regular mail, and be sure to put your name, telephone number, and address on the back of each piece of artwork so that the syndicate editors will know to whom the work belongs if it gets separated from your cover letter.

Always include a cover letter, and in it briefly describe your new comic strip. Do so in a way that will make the editors want to read it. Use a hook (see page 74). Mention any published credits or art education. If you don't have either, just talk about the strip. Limit the cover letter to one page, and here's a bit of incredibly obvious advice that I'm going to say nonetheless: Always type your letters. If editors see a handwritten letter, they'll assume you're either a rank amateur or a prisoner without access to a typewriter. Include your résumé only if you have published credits, otherwise skip it and just send the goods with a cover letter.

If you're in your twenties, find a way to mention this. It's a plus. Syndicates will assume, often incorrectly, that this means you're funnier and fresher than people in their fifties. And, never, ever send original art; send clean copies. You should hear back within two to three full months.

HOW MANY DAILY AND SUNDAY STRIPS SHOULD I SEND?

Send two weeks' worth of inked daily comic strips and two weeks' worth of rough, penciled dailies. Remember, there are six dailies in a week. Always present the strips with your strongest jokes first. Don't save the best for last, because those strips might never be read. Also, enclose a couple of

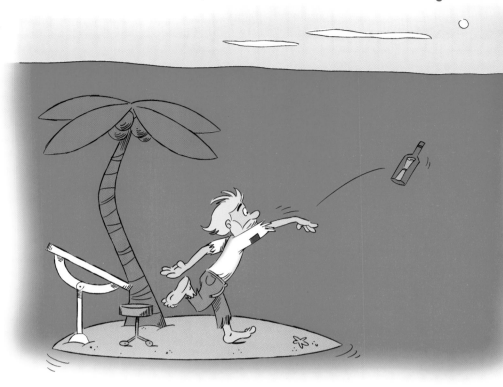

Sunday strips. (You can leave out the color on these.) Some syndicates don't require Sunday strips for the initial submission. Contact each syndicate directly and ask for their submission guidelines. (See page 142 for names and addresses of the major syndicates.)

Xerox and reduce the strips so that they fit on standard 8½ x 11-inch paper, one strip to a page as editors prefer. Using a fancy binder *is not* a good idea. It screams, I'm new at this! A simple binding will do; let your work speak for itself. Copyright your material if you like; even put a small copyright symbol and date on the bottom if you want, but for heaven's sake, don't be a rube and write, "Property of John Doe. Unauthorized use will be. . . ." You'll seem ready to instigate a lawsuit, which'll keep your work very safe because then no one will read it.

If the editors like your strip, they'll ask to see more samples, so be ready with some backup. Then, the syndicate may offer you a meager amount of money,

during an option period, to test you out. If that goes well, they may offer you a contract, and that could mean serious bucks—in which case, I get ten percent.

SUBMITTING SPOT GAGS TO MAGAZINES

When sending spot gags, send them in batches of six to eight illustrated gags. Follow the same instructions as with the daily strips for artwork format, submission, and labeling. Keep a filing system by numbering your cartoons. For example, you might send gags 1 through 6 to publication A, gags 7 through 12 to publication B, and gags 13 through 19 to publication C. If publication A buys gag 3 and sends back the rest, you now have 5 more gags to send to publication B. If possible, sell only "first time rights," which is the right for a magazine to publish your cartoon first. Afterwards, this allows you to resell that same cartoon over and over again to other publications (just not for first time rights anymore).

The Character Sheet

Okay. Here's the question: What goes on top of the package of dailies and Sundays that you submit to the syndicate?

 a) A tiny present to make the syndicate editor feel special.
 b) A self-portrait, because they need to know what you look like.
 c) A character sheet showing who all the characters are in your comic strip.
 d) Some of (a) and part of (b).

If you picked (c), you're right. A character sheet provides you with a way to quickly introduce your characters to syndicate editors. It shows all the characters with a very brief description under each one. Be clever in your descriptions; be brief, and be funny. Use the character sheet as the cover of your package of dailies.

"MOLLY'S CLASS"

MIKE
Molly's egotistical suitor. He can't figure out why Molly doesn't think he's terrific.

MOLLY
A third grade teacher trying to teach a bunch of kids who's only mission in life is to drive her nuts. She likes Mike—she just likes him more from a distance.

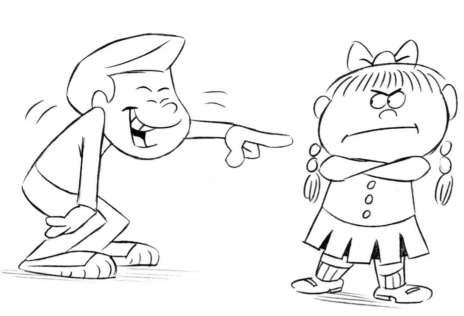

KYLE AND BETTY

Two of Molly's students who are always trying
to get even with each other. Don't ask them
what started it—they wouldn't remember.

TERRANCE

He gets confused easily and, with the
help of his classmates, stays that way.

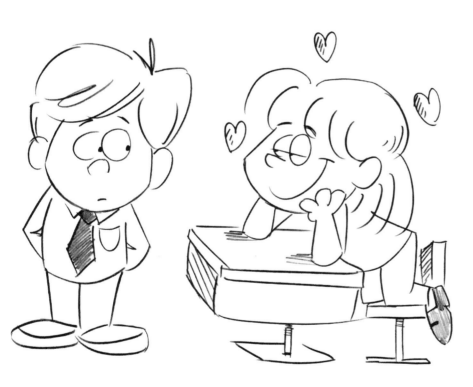

CHIP AND MARIA

Two more of Molly's students. Maria
is planning on marrying Chip whether
he wants to or not.

MR. WHEATON

The principal. He has a knack for
showing up just when everything
is out of control. He does the
best "Tsk, tsk" in the business.

Where to Submit Your Stuff

See these guys? They're the comics editors at the syndicates. Only they will determine if a comic strip is funny. I encourage you to submit your stuff simultaneously to all of the syndicates. However, I wouldn't inform them of that fact. Do they inform you when they're looking at a comic strip that's similar to yours? You might be thinking, But what if more than one syndicate says yes to my strip at the same time? Are you kidding me? You're going to worry about a problem like that? (That's like worrying that your cholesterol is too low.) Most people would kill for that problem. You *want* that problem. And, I'll deal with it on the next page.

Anyway, here's the list of the country's top comic strip syndicates. Address your submissions to the Comics Editor.

King Features Syndicate
235 East 45th Street
New York, NY 10017

Tribune Media Services
435 North Michigan Avenue, Suite 1500
Chicago, IL 60611

United Media
200 Madison Avenue
New York, NY 10166

Universal Press Syndicate
4900 Main Street
Kansas City, MO 64112

Creators Syndicate
5777 West Century Boulevard,
Suite 700
Los Angeles, CA 90045
Known for allowing artists to retain authorship of their work.

Los Angeles Times Syndicate
218 South Spring Street
Los Angeles, CA 90012

Washington Post Writers Group
1150 15th Street, NW
Washington, DC 20071-9200

THE BIDDING WAR

Supply and demand is a beautiful thing. When two syndicates want your stuff at the same time, whoever gives you the best deal wins. Even if one syndicate is nicer, go with the nasty syndicate that gives you the best terms—which may not necessarily be monetary. For example, terms may include a better licensing or marketing plan. However, perhaps the most important criteria are: Who wants it more? Who believes in it more? Who'll get behind it with the most force? Usually, it's the syndicate that's willing to put up the most buckeroos. Still, if the other one has a far better marketing plan, I'd suggest you consider it very carefully, too.

HOW YOU GET PAID

Typically, the comic strip artist and the syndicate are paid a fee by the newspapers that run the strip. They pay one sum for six dailies and a larger sum for the Sunday strip. The artist and syndicate split the fee evenly. Comic strips can be syndicated in any number of newspapers, from a few to over 2,000 papers a day. Then there's the revenue from character licensing, which can include plush toys, greeting cards, books, games, television shows, commercials, and print ads.

THE NEGOTIATIONS

When it comes time to negotiate, I suggest you hire an attorney who specializes in intellectual property rights. You may not know such an attorney, but you probably know someone who knows an attorney. Even if that attorney argues traffic tickets for a living, he or she will know someone who can help you. However, I wouldn't get a legal referral from the syndicate—not even if it would ensure world peace. And here's another suggestion: Communicate with your attorney before he or she negotiates your price with the syndicate. Don't leave it up to your lawyer to determine what price you're willing to live with and what's a deal blower.

Alternative Paths to Syndication

What happens if your work doesn't get picked up for syndication on your first or second attempt? You could do one of three things. You could keep trying, as many have, some quite successfully. You could lock yourself in your room and eat chocolate until you need The Jaws of Life to remove you from your bed. Or, you could take an alternate route.

Any alternate route that establishes your comic strip in another forum gives you the advantage of being published, which is a *big* advantage. You gain experience. You amass a body of work. You become part of a community of working artists. You develop a track record for being able to deliver. Syndicates are always impressed by a person's ability to deliver; they have a constant fear that their artists may run

dry. So, by publishing in an alternative forum, you demonstrate the ability to keep your strip going, and funny, for months or even years. That's no small feat. In addition, you can work out any bugs in your strip. Comic strips should get better over time as you become more familiar with your characters. Plus, you might develop a small, but loyal, following, and this would also impress the syndicates.

The most common alternative methods are self-syndication and local papers. Self-syndication is when you approach newspaper editors yourself and try to get them to take on your strip. It sounds like a good idea, but it's a rough road, and I wouldn't recommend it unless you truly feel you're up to the task. However, this doesn't mean that it's not the

right choice for you. The more papers that take you on, the more money you make, and you don't have to split it with a newspaper syndicate. Plus, if you make a successful go of it, the syndicates may take a serious second look at your stuff.

The disadvantage to self-syndication is that all of the expenses are yours alone. Mass mailings with follow-up phone calls may not be enough to persuade busy newspaper editors. You may find that, in order to sell your strip, you need to take road trips to meet with editors face to face. All this while still producing your strip every day. Then, there's the bookkeeping and collecting. If you have a spouse who might want to take on some of these responsibilities while you cover the creative end,

this might be a good plan for you, although it can be a lot of work.

Local papers provide the other alternative path to syndication. There's practically no money in doing a strip for a single local publication. However, you're not doing it for the money—not yet, that is. You're doing it to gain all of the advantages you get from self-syndication, with none of the drawbacks. In addition, if you've never been published, having a strip in a local paper could be an important credit. You'll probably have an easier time reaching the comics editor at your local paper than at the *New York Daily News.* Then, once you've gotten your strip up and running, you can use your best published samples to approach the major syndicates.

MULTI-PANEL STRIP — COPYRIGHT NOTICE — E-MAIL ADDRESS — SIGNATURE

COPYRIGHT NOTICE — E-MAIL ADDRESS — SINGLE-PANEL STRIP — SIGNATURE

DETAILS

As with most things, the little details are always important. Never forget to sign your comic strip. The signature should go inside of one of the panels. If you have a partner, that name is listed, too. But, only last names. E-mail addresses and copyright notices should appear in the gutters between the panels, *except* on single panel cartoons. In that case, all the information goes inside the single panel. Syndicates will generally give you a roll of copyright logos to affix to your work, but you can also handwrite the logo.

Some syndicates encourage their artists to post an e-mail address on their strips. Some artists end up hating this because the sheer volume of inquiries can force them to hire people to respond to all the messages. If you don't answer a message, the e-mailer will hate your guts and stop reading your strip. It's a classic no-win situation. Plus, many e-mailers aren't really comic strip fans, just computer devotees looking for another reason to log on to the Internet.

Working with a Partner

Usually, a comic strip partnership is a 50/50 split, with one partner acting as the artist and the other as the writer. If there are two artists initiating a strip, it's like having two drummers for a rock band. One is plenty, and two is too many. The advantage to working with a partner is that no one is the boss. You share the work load but can specialize in what you do best. The story sessions can be a scream. You can strategize your business decisions together and network more effectively. Good partnerships are terrific.

The disadvantage is that one partner cannot make a decision without the other. Plus, you both may end up less than thrilled with each other. Partnerships also have legal liabilities that you should look into. And, here's a really troubling problem: What if your partner is always late? I've heard stories of comic strip writers coming in late with their materials time after time. What could the artists do? They had to wait for the jokes. In these cases, it didn't take long before the strips went under. In addition, what if your partner's work is suffering, what can you do? Fire him or her? Nope. You're a *partner* not a *boss,* remember?

Here's how to get a partner without really getting a partner: Write and illustrate the strip yourself. If it's a lot of work, grit your teeth, because it won't last forever; once you sell your strip and get it up and running, you can hire a ghost illustrator and buy freelance gags from joke writers. This way, you're still the owner, and everyone else is working for you. Many of the top comic strips work this way.

STORY SESSIONS

"DISCUSSIONS"

Rate Your Own Gags

By rating your jokes, you'll create a backlog of material that'll allow you to yank out a usable gag in a pinch. Every comic strip author needs a heavy duty reserve because of the relentless pace in which comic strips consume material. Rate each gag for humor with one, two, or three stars—the more stars, the funnier the gag.

A three-star joke is a *go*; don't tinker with it too much because it's basically all there. A two-star gag is one that needs some work; you're confident there's a joke in there, perhaps it needs a stronger setup line or an alternative punch line. Even a one-star gag isn't useless; you may like the area with which the joke deals but not the joke itself, so you keep it as a premise for future gags.

You should also create a filing system for your jokes. If you write a family comic strip, you might categorize your jokes under headings such as work, chores, neighbors, leisure, kids, husband, wife, and so on.

Rating your own jokes will help you figure out on which day you should run them. The best ones should run on Sunday and Monday (when newspaper readership is highest), the solid ones should run Tuesday through Friday (when the readership is strong); and the so-so gags should run on Saturday (when readership is lowest).

Holiday and Seasonal Gags

Your readers will feel that you're more tuned in to them if you can come up with gags that have some timely relevance to their day-to-day lives. An effective way to do this is by celebrating the holidays with readers through your comic strip. Christmas, Halloween, Thanksgiving, Valentine's Day, Mother's Day, and Father's Day are among the most popular holidays. (Note that you must be careful if your strip is in a substantial number of foreign newspapers because American holidays, such as Thanksgiving and the Fourth of July, aren't necessarily celebrated in other countries.)

Seasonal gags also make a welcome diversion; in the winter, sprinkle your strip with jokes about shoveling driveways and having snow fights. Do this even if it's a snowless winter. People always assume it's snowing in some part of the country, even if not in theirs. In the summer, it's off to the beach and going on road trips.

Keep in mind that it's risky to incorporate gags about current events into your strip. A news story may change or take a morbid turn. In addition, your strip will be published long after those stories break, since you have to draw your gags four weeks ahead of publication for dailies, and eight weeks ahead for Sunday strips. It's hard to be timely with a schedule like this.

Meeting Deadlines

Comic strips are ravenous creatures. They must be fed 365 days a year. They appear every weekend, even on Sundays—*especially* on Sundays. They must appear on Christmas Day, when you're on vacation, when you're sick, and when you're taking care of a sick child. That comic strip must be there every day. You can't let that page go blank—ever! How do you feed the beast and still have a life? Nobody has figured that out yet, but there are a few ways to give yourself some breathing room.

- Build up your lead time. Write a few *good* extra gags each week, and keep them in your files. After a few months, you'll have a week's worth of extra daily strips—and that's a week's vacation for you.

- The same goes for drawing. Draw an extra gag every week or two. Make it part of your routine, like putting money away in the bank. When an emergency comes up, or when you just need to take time off, you'll be able to cash in on your efforts.

- If your strip is an established one, buy gags from freelance writers, whom you can meet by networking in the National Cartoonist Society (see page 157). Also hire an assistant artist to do the inking and lettering on your strip; this will lighten your load considerably.

Writer's block will strike. Count on it. Your brain will turn to lumpy pieces of cornmeal when you least expect it. I've heard the popular advice of those who say that when you're stuck, you should go for a walk and take your mind off of your work. Come again? You've got to come up with a strip by the end of the day, it's two in the afternoon, you've only got three hours left before the FedEx guy arrives to pick up your package, and their suggestion is to take a walk? What planet are these people from? Here are my tips for dealing with writer's block:

1. LET YOURSELF WORRY. It's a reasonable thing to do with a deadline hanging over your head. Plus, it's a sensational motivator.

2. WORK THROUGH IT. That's right. Stick with it. Write crummy gags until you break through. If that doesn't work, go to number 3.

3. WORK ON SOMETHING ELSE. This will keep your mind in work mode but release the pressure on you to solve the immediate problem.

4. GO TO YOUR FILING SYSTEM and pull out a gag that works. Hey, they're *your* jokes—if you need one, take it.

5. KEEP COMING BACK TO YOUR PROBLEM. Attack it from new angles. Change the setup line, or give the other character the punch line.

6. WRITE A COMPLETELY NEW JOKE. This is often the best solution. When something won't work, sometimes it's because it's not meant to be. By switching gears, you'll channel all your energy and frustration down a new path, and if that path holds any possibilities, you're likely to solve your problem on your first or second attempt.

Building Character Name Recognition

You want your readers to know the names of your characters. It builds familiarity and loyalty. Your readers' choice of favorite character may surprise you; it might not be the main character but a supporting one, who shows up once every week or so.

However, it's hard for readers to have a favorite character if they don't even know the characters' names. So, insert your characters' names inconspicuously—but as often as possible—into your comic strip.

When choosing a character's last name, try to come up with something unusual, otherwise you'll get mail from people with that same last name. They'll be angry, or they'll want you to send them, for free of course, the original art of that strip. Neither of these is a wonderful situation.

Who Will Make It As a Professional Cartoonist?

ONE OF THESE GUYS...

- Spends lots of time talking about his new comic strip but no time actually working on it.

- Devotes all his energies to drawing but none to writing.

- Takes rejection personally and never tries again.

- Makes no contacts with any other cartoonists.

- Is only interested in selling his own comic strip and doesn't pursue an apprenticeship on someone else's strip as a way to learn.

- Works very, very slowly, spending years coming up with one comic strip idea.

THE OTHER...

- Reads books and publications about cartooning.

- Joins cartooning clubs and societies.

- Redoubles his energies when he receives a rejection and learns from any critiques he receives.

- Comes up with a new comic strip idea if his last one didn't catch fire.

- Takes art classes.

- Solicits advice from professionals and seeks work from them.

- Doesn't just wait for his big break but gets published in other mediums, developing a track record.

Answer: It's the guy with the torn jeans.

How to Protect Your Ideas

Most cartoonists are interested in protecting their ideas. And why not? Just one good idea, such as the concept for *Garfield,* is all anyone needs in a lifetime. So, how do you do go about protecting your ideas? Wallace Collins is an attorney in New York City who specializes in intellectual property rights, copyrights, and trademarks. Here, he shares his expertise.

Chris Hart: What are intellectual property rights?
Wallace Collins: The easier question is: What is a copyright? The creator of a character or a drawing—under the copyright law, the creator of any work of art—owns the copyright of that work from the moment of creation. And he or she can only assign away rights to it by signing something in writing, which is why you have to be careful of what you sign once you create something. The copyright is only one form of intellectual property rights. There are also trademarks, which relate to names and slogans. And there are patents, which are inventions of more of a mechanical or chemical nature. So, all of those are intellectual

property rights, which basically means rights that were created out of intellect, as opposed to personal property rights, which are rights to things that you own, or real property rights, which are of real estate in land and buildings.

CH: If you want to apply and pay the nominal fee to get your stuff copyrighted formally at the Library of Congress, would you call the information operator in Washington, D.C., and ask for the copyright office?
WC: You'll get one of those automated answering machines, and they tell you what forms you need; you tell them your address, and they send you the forms. For copyright, it's pretty straightforward. Trademark is a little more involved.

You own certain rights, but the registration is more of an evidentiary process really, and it backs you up. It helps you get into federal court and collect legal fees. There are things you get. So there's a need to understand that you own rights before you get any papers. The papers evidence the rights that you're claiming.

CH: What about a "poor man's" copyright—the idea of sending something to yourself in a sealed envelope to get a postmark stamp that proves the date on which you created it? Or, even a registered receipt, where you sign it yourself? Is there any effectiveness in that?

WC: It's a form of proof that, as of a certain day, you created the work, if that ever becomes an issue. But how poor do you have to be to not afford the $20 [copyright] filing fee? There are certain benefits to doing the filing. First of all, if you're going to sue someone for copyright infringement, you need to have filed that form—so whether you do it now or do it later, you're going to have to do it before you sue anyone anyway. And then second of all, the way the law is written, as far as legal fees and certain damages, if you don't file that form from within 90 days of when you offer the work for sale to the public, then the judge is precluded from awarding you statutory damages or legal fees.

So there are limitations by not filing the form. It doesn't give you any more of a copyright than you had, but it kind of gives you these ancillary rights to collect legal fees, and these kinds of things can actually be very important in a copyright infringement [case]. If you win, but you've got to pay your lawyers out of the money you win, that's going to erode your winnings.

CH: Suppose you have a partner—you're going to collaborate with someone else. Do you both share the copyright?

WC: Yes. Again, there's a way the copyright law works that if, in fact, people are contributing to the expression of the idea, as opposed to the idea itself, then they are co-owners of the copyright, and because again, as I said earlier, the law requires that anyone who wants to transfer rights has to transfer them in writing, it's deemed to be equal co-owner-ship of the whole work.

CH: So you'd have to specify if it weren't a 50/50 split [in writing].

WC: There was a big case last year with Harry Connick, Jr., and a co-songwriter, and that's what the issue was. They'd done one album in 80/20 [partnership] and they had a written agreement. They did another one, 80/20, written agreement. They did a third one; they sent out the agreement, but it never got signed, and then, later, the record label was paying a full 50 percent to the co-writer and Harry Connick sued, saying that it was an 80/20 split. The other writer said he'd never agreed to that. And the courts basically said that there was no written transfer in this case and therefore deemed it to be a collaboration, indivisible 50/50. If it were three people, it would be a three-way split, but it's an even one, because the courts don't want to have to try to figure out whose contribution was greater or lesser.

CH: This may sound like a very basic question, but in fact, I think a lot of people misconstrue this. What can and cannot be copyrighted?

WC: What you *can't* protect is the idea. So, if you say, "I have a great idea to write the Amy Fisher story," you can't stop everyone else from writing the Amy Fisher story, partly because it's just public knowledge as to the plot line, although each person will express it differently. Soap operas are similar. Sitcoms are similar. You can't protect the idea of, say, a guy and his three friends hanging out. But, your *expression* of this idea will be different from everyone else's expression of it. And *that's* what's copyrightable. It's the *way* you express that idea.

CH: Until about 10 years ago, syndicates always insisted that they owned the comic strip. If you were the creator, you'd have to sign over ownership to the syndicate. Now some syndicates are allowing authors to retain ownership of their comic strips. How important is it to own your own property?

WC: To the extent you can, it's better [to own it]. The further back in time you go, the more likely it is that the company would get all the rights to the character. There are even certain current, fairly big comics now for which I've heard complaints about people signing away all of their rights. But I've handled something recently with a fairly big television company for which my clients were hired to draw—to come up with five spots featuring this particular character that they created for a parody of 1950s style commercials—and one of the big negotiating points was that we were only giving rights on those commercials. We were not giving merchandising rights to the character, so [the television company] couldn't turn around and then hire someone else to make more commercials with [my clients'] character. It was a tug of war, but the issue for the writers was that they didn't create this character to be paid for five spots and then ditched, while the company still had rights to the character. So, we needed to negotiate.

You need to be careful with the agreement you sign because the odds are, if the other person is giving you the agreement, it's going to favor them and read, You give me all rights in everything for-ever. What you want to do is take that lump of clay and carve it into a nice statue that is pleasing to everybody, because you don't want to have a situa-tion in which you've given away the rights to every-thing. You want to limit it to certain things if you can.

Copyright rights are divisible. That's the key. So, you can divide it up. You can give one person the

rights to put [your character] on T-shirts and nothing else, and another person [the rights] to put it on CD-ROMs and nothing else. You really can divide up the rights into as many different media formats as you can conceive of, and make individual deals, which I think can be a better way to go.

CH: With a time limit, I suppose, because what if they're doing very poorly with it?
WC: A time limit or a minimum financial guarantee, like $10,000 a year, and maybe you'll let them go on and on, because if they're not making any money, as long as they pay you. . . .

CH: A lot of times, comic strip artists will be toiling away for years and suddenly they get a contract, and if the thing takes off it could mean a lot of money. A lot of comic strip artists have come from nowhere to become very, very successful. How important is it for someone like that to spend the money to get a legal opinion before signing a contract to which they could be held forever?
WC: As a general rule, I tell clients, Don't sign anything other than an autograph unless I see it first. You just can't rely on what anyone else is interpreting it to say. And, the copyright law says that unless you sign it in writing, you can't assign any rights. So, in a way, even the law tries to make you think twice. You can't just give it away; you've got to sign something to give it away. Which kind of forces the creator to take a step back and say, Well

maybe I should have someone who understands this stuff look at it. Fame without fortune is pointless. You'll be a famous writer, but you'll have given away everything from which you can make money.

It's not that you're being cynical, or that you think anyone will rip you off, but other than the copyright law, there are no laws in the marketplace of creation. It's the law of supply and demand. Whatever they'll pay you is what you'll take. And, most creators take very little. But, at least if you retain your rights, then if your rights become more valuable later, you'll get more later. If you just give [your rights] away for $100 now, you'll have a hard time getting a second bite at the apple later.

I think the key is to believe enough in your work to believe that there's some value there. It doesn't mean a lawyer's going to say, Let's demand a million dollars and blow your deal. That's not good for you, and hopefully, the lawyer's going to do what's good for you. The idea is to make the deal. Maybe you're not making a lot of money up front, but if money is made later, you want a piece. That's usually what I find myself doing—clarifying what the artist gets later if this is successful—because, usually, that's the vague part of it. Otherwise, it's everything about what you're giving to them and nothing about what they have to do for you.

I highly recommend legal advice if for no other reason than I can tell you, for sure, that it's much easier to fix a bad deal than it is to try to get out of a bad deal. You can't unsign a contract. You go to a lawyer after [signing something] and say, "I signed this awful agreement. What can we do?" Well, maybe we can try to renegotiate, but the other side doesn't have to. They've already got their deal. When you haven't signed anything yet, you've got 100 percent of the power, because you can walk away from the table, and that's your most important asset. If you think you've got value, and they think you've got value, then they won't let you walk away from the table. They'll give you a better offer.

Oftentimes, when I meet with clients, the first thing I have to do is bolster their self-esteem, because they've been so beaten down, and as you've said, they've been struggling for so long, that they barely believe they're worth anything. And, that's the perfect time to be abused. You think, "Oh well, I don't want to blow this deal"—but aren't you blowing it if you give away everything for nothing? Didn't you really blow it? You worked for 10 years, and you got an opportunity, and you gave it all away for nothing. If they really want you—I'm not talking about asking for a million dollars, I'm just talking about working out a fair arrangement—most companies will. If they want you enough to ask you, they want you enough to deal with you.

Cartooning Resources

Most of the comic strip associations listed below have local chapters, some of which may be near your neighborhood. You don't have to be a professional to join them; they usually offer associate memberships to aspiring cartoonists. It's a good opportunity to network with established cartoonists and to meet others at your own level. The door's wide open, so jump in! Also listed are some useful industry publications.

ASSOCIATIONS

The National Cartoonist Society (NCS)
Membership Chairman
Columbus Circle Station
P. O. Box 20267
New York, NY 10023
The premier body of syndicated comic strip artists. The author of your favorite comic strip is likely a member. By joining, you'll probably have the chance to meet him or her, as well as your contemporaries at NCS hosted events. There are local chapters throughout the country.

Association of American Editorial Cartoonists
4101 Lake Boone Trail, Suite 201
Raleigh, NC 27607
Geared toward editorial cartoonists and those aspiring to that field.

ASIFA (International Animated Film Society)
725 South Victory Boulevard
Burbank, CA 91502
The premier organization for those interested in a career in the animation industry. There are local chapters throughout the country.

PUBLICATIONS

Cartoonist Profiles
P. O. Box 325
Fairfield, CT 06430
A magazine for aspiring and professional cartoonists, with an emphasis on comic strip syndication.

Gag Recap
12 Hedden Place
New Providence, NJ 07974
This magazine contains information on magazine spot gags and markets for cartoonists.

Animation Magazine
30101 Agoura Court, Suite 110
Agoura Hills, CA 91301-4301
Geared toward industry professionals.

INDEX

Christopher Hart is the best-selling author of Watson-Guptill's most popular how-to-draw books, covering everything from cartooning to animation, and comic strips to comic books. Hart began his career in animation working as a character designer for an animation studio while still in high school. He attended the Disney character animation program at The California Institute of the Arts and then went on to earn his B.A. at New York University's Film School. In addition, he furthered his studies at The School of Visual Arts and The Paier College of Art.

Hart worked on the staff of the world famous *Blondie* comic strip and has been a regular contributor to *Mad Magazine.* His work has also appeared in numerous magazines, such as the popular *Highlights for Children, Crayola Kids,* and The National Wildlife Federation's *Ranger Rick.* He has been a member of The National Cartoonists Society, ASIFA (The International Animation Society), and the Writer's Guild of America.

In addition to his work in cartooning, Hart has written comedies for many of the top film and television studios, including MGM, Paramount, Fox, NBC, and the Showtime Cable Television Network. He lives in Connecticut with his wife and daughters.